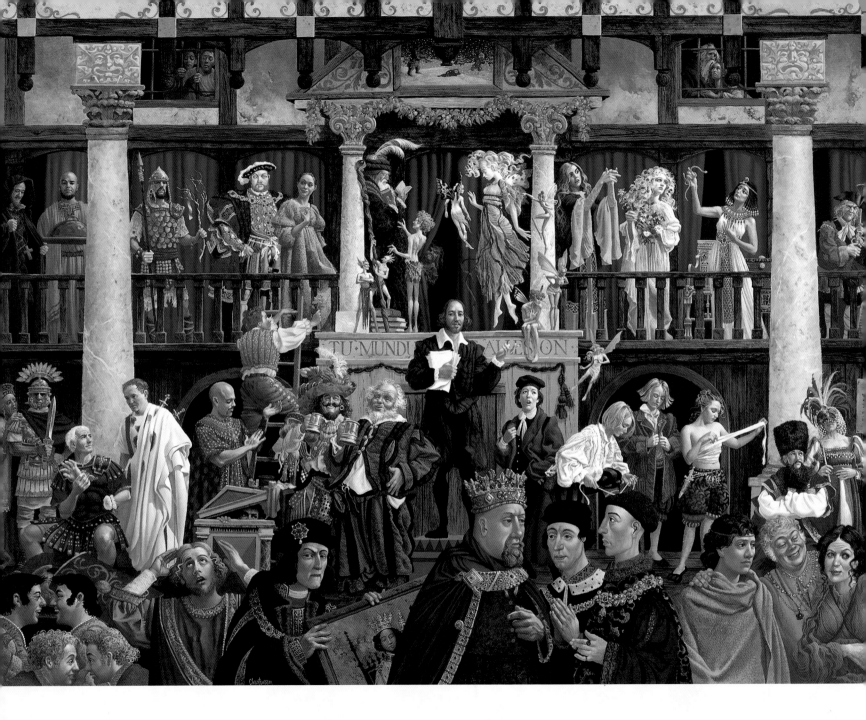

ALL THE WORLD'S A STAGE

KEY: PAGE 110

BY RENWICK ST. JAMES ☙ ARTWORK BY JAMES C. CHRISTENSEN

WITH AN INTRODUCTION BY FRED C. ADAMS
Founder and Executive Producer of the Utah Shakespearean Festival

A Shakespeare
SKETCHBOOK

THE GREENWICH WORKSHOP PRESS

A GREENWICH WORKSHOP PRESS BOOK

Copyright ©2001 by The Greenwich Workshop, Inc.
All art ©2001 James C. Christensen

Published by the Greenwich Workshop, Inc. One Greenwich Place, P.O. Box 875, Shelton, CT 06484.
(203) 925-0131 or (800) 243-4246.

Library of Congress Cataloging-in-Publication Data
St. James, Renwick, 1954-
A Shakespeare sketchbook / by Renwick St. James; artwork by James C. Christensen;
with an introduction by Fred Adams. p. cm.
ISBN 0-86713-059-8 (alk. paper)
1. Shakespeare, William, 1564-1616—Stories, plots, etc. 2. Shakespeare, William, 1564-1616—Illustrations.
I. Christensen, James, 1942- II. Title.

PR2997.P6 .S7 2001
822.3'3—dc21 2001016154

Limited edition prints and canvas reproductions of James C. Christensen's paintings are available exclusively
through The Greenwich Workshop, Inc. and its 1200 dealers in North America. Collectors interested in
obtaining information on available releases and the location of their nearest dealer are requested to visit
our website at www.greenwichworkshop.com or to write or call the publisher at the address above.

Jacket front: *Titania and Bottom*

Book design by Claire Zoghb
Printed in China
First Printing 2001
1 2 3 4 5 04 03 02 01

CONTENTS

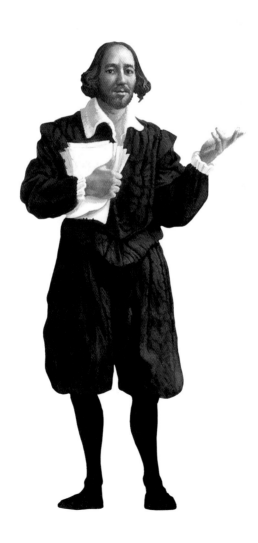

INTRODUCTION
✤ 6 ✤

THE COMEDIES
✤ 8 ✤
THE PROBLEM PLAYS 36

THE TRAGEDIES
✤ 46 ✤

THE HISTORIES
✤ 77 ✤
THE ROMAN PLAYS 95

THE ROMANCES
✤ 100 ✤

INDEX
✤ 112 ✤

INTRODUCTION

As the world recently ushered in the next thousand years of human history, the people of Great Britain named William Shakespeare the "Man of the Millennium," placing him above such notables as Isaac Newton, Leonardo da Vinci and Galileo Galilei, to name just a few. These men contributed impressive works and ideas to humankind: mathematical laws that explained the world around us, paintings and sculpture that shaped our hearts and discoveries that extended our horizons into the universe. Why would a mere playwright and poet whose legacy is simply "words" be honored above them? Because Shakespeare was not a mere playwright and poet. He left us more than ink on paper. He bequeathed to us a raft of characters, relationships and ideas, which express, question and illuminate the human condition. His gift to us was the power of his imagination and a vision and understanding that still engages

our minds, stimulates our senses and touches our souls.

Included in his legacy are one hundred fifty-four sonnets, as well as two major poems and a smattering of minor poetry, all of which is still compelling to our twenty-first century sensitivities. But it is his collection of plays, some thirty-seven that we know of, that draw us to him. We clearly recognize our lives, and our professions, today. Lawyers are surprised at Shakespeare's hundreds of references to the law. Military men say he has an affinity with them since his plays have hundreds of detailed references to the soldier's life, not to mention hundreds more references to sailing and ships —and this from a man who probably never went to sea! Perhaps he was a botanist (his allusions to trees, shrubs and greens, number over three hundred) or a trained musician (whose plays are filled with references to music and musical instruments). And the compelling argument in each and

every one of these theories is that Shakespeare used professional terms with the assurance, knowledge and accuracy of a trained expert.

We long for what Shakespeare has to say and for his sweeping metaphors and piercing commentary. *A Shakespeare Sketchbook*, with the delightful artwork of James C. Christensen, matched with lively tellings of the plays and on Elizabethan life, fills that longing.

Some of the artwork in this book is taken from two of James Christensen's paintings (*Shakespeare's Island* and *All the World's a Stage*) created for the Utah Shakespearean Festival. *All the World's a Stage* was commissioned by the Festival to celebrate its fortieth anniversary and its receipt of the Tony Award® for Outstanding Regional Theatre.

FRED C. ADAMS
Founder and Executive Producer
of the Utah Shakespearean Festival

In forty years of producing the Bard's works at the Utah Shakespearean Festival, I have found that Shakespeare is very accessible, and that audiences enjoy him even more if their imaginations can be piqued just a bit—with both word and image. That is what this book admirably accomplishes. It combines the artistry of the painter with the artistry of a consummate writer to engage our imaginations and in doing so, makes these stories and their characters totally accessible. We recognize some of the situations and people in our own lives. William Shakespeare tells their tales, and our tales, through word and speech, and James C. Christensen brings them to universal life through pen and paint.

A MIDSUMMER NIGHT'S DREAM

Once upon a time in Athens, Theseus, the duke of Athens, and Hippolyta, queen of the Amazons, were impatiently awaiting the day of their nuptials. They went about their eager waiting with poetical restraint and fortitude, just as royalty ought to.

The folk around them, however, have been touched by the more antic version of love. Demetrius loves Hermia. Hermia loves Lysander. Lysander loves Hermia. But Egeus, Hermia's father, wants her to marry Demetrius. Helena, Hermia's friend, loves Demetrius. Demetrius used to love Helena, but now he's very cozy with Egeus and wants to marry Hermia. Hermia likes Demetrius just slightly less than dragon spit. Hermia wants Demetrius to go away. Egeus wants Lysander to go away. Oh, and in just a little while the queen of the faeries is going to fall in love with an ass.

If this sounds confusing, you're right. Love is a kind of lunacy and no one is immune. Even Egeus is in love with his own opinions.

In a move that seems to carry the father-knows-best idea to extremes, Egeus takes Hermia before the Duke demanding adherence to the ancient Athenian law stating that a woman must marry as her father decides or face death or a convent. Lysander, Demetrius and Egeus spend some time insulting each other and being contrary. Theseus doesn't much care for Egeus's heavy-handed way, but the law is clear. He tells Hermia she has until *his* wedding day to decide whether she'll take a) Demetrius, b) death or c) the convent.

Theseus calls Egeus and Demetrius into a private conference, which gives Lysander and Hermia the perfect opportunity to plan their escape. Love hasn't made these two any more astute, because they decide to run away by going through the forest in the dark, and then, when they meet Helena, they tell her of their plan.

Without Hermia and her wealthy father to distract Demetrius, they believe he may once again court Helena. Helena (surprise, surprise) doesn't find much that's complimentary to herself in this. In a fit of spite and some very twisted reasoning, Helena tells De-

metrius of the lovers' plan.

Meanwhile, back in the unfashionable side of Athens, a group of tradesmen are planning to perform a play for the duke's wedding festivities. They decide to go into the forest that night to rehearse and avoid the kibitzing of their neighbors.

So Lysander and Hermia sneak into the woods and promptly get lost in the dark. Demetrius goes into the forest after Hermia. Helena follows Demetrius. By this time, the forest has nearly as many people in it as trees.

And, of course, in any forest worth the name, there are more faeries and sprites than you could shake a wand at. These are not Tin-

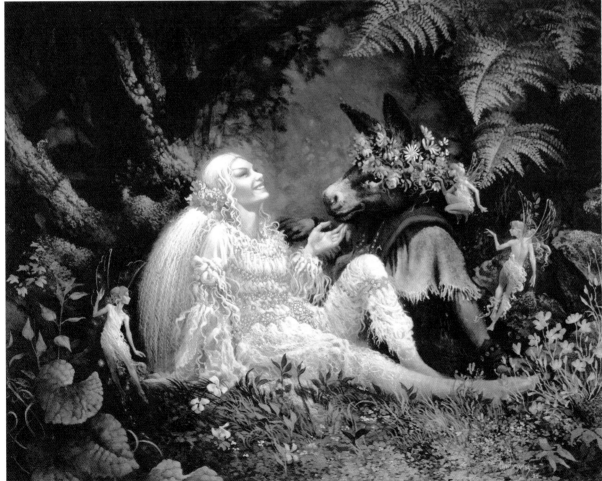

Faeries, Sprites and Spirits of the Air

Before the extended car chase was invented, writers needed some way to let the audience know that the normal rules of the world had been suspended. Magical time, when faeries or spirits of the air appear, is outside the control of humans and is the cue that we should not expect a normal progression of events.

Supernatural beings could effect changes in the twinkling of an eye, enchant divided lovers, befuddle contentious rivals and show, by their mischief, how foolish humankind can be.

Puck, also called Robin Goodfellow, is servant to Oberon, king of the faeries in A Midsummer Night's Dream. *He is witty, mischievous and a little dirty-minded. He's an earthy spirit and it's likely that most of Shakespeare's audience believed in him—at least when they went into the woods (and anyone who's ever gone on a less-than-perfect camping trip knows that faeries are still out there waiting to waylay the unwary). Puck can bewitch and bewilder, but much of what he does is moonshine and monkey business.*

Ariel, the air spirit from The Tempest, *is another being altogether. Locked within the trunk of a pine by the witch Sycorax, he has spent a dozen years confined and tormented. Prospero frees him, but at a price: for the same term of years that he was imprisoned, he must serve the magician Prospero. It is Ariel's enchantments, controlled and guided by the purposeful sorcery of Prospero, that create most of the magic in* The Tempest.

Puck seems happy enough doing the bidding of Oberon, occasionally throwing his own oddball curve into the magical mix. It is Ariel we want to see set free. The enchantments he performs for Prospero are small beer, just "stuff." The moment that Prospero gives him his freedom, we wonder what couldn't a free spirit of the air do? Ariel is like imagination itself: limitless, boundless and full of wonder.❦

kerbell faeries who want you to clap your hands and believe, but mischievous nature spirits with their own agendas and precious little respect (if any) for humankind.

To make matters more unsettled, the king and queen of the faeries, Oberon and Titania, are engaged in a marital battle royal. Titania is caring for a little human boy whose mother, now dead, had been a friend of Titania's. Oberon is jealous and wants her to give him the boy to be his page. Titania has refused, and their dispute has turned the entire natural world into a clamor of flood, storm and upheaval.

Oberon is determined to punish Titania for denying him the little human child. He sends his servant Puck to collect a magical flower, the juice of which causes the recipient to love the first thing seen upon waking. While Oberon waits for Puck to return, he sees Helena pursuing Demetrius and takes pity on her. When Puck returns, Oberon tells him to seek an Athenian youth and to squeeze the juice of the flower on the young man's eyelids when he falls asleep.

By this time, Lysander and Hermia have floundered about so long in the dark that they're exhausted. They lie down but Lysander wants to get fresh, so Hermia asks him to lie some distance away for modesty's sake. Thus, when Puck finds this Athenian youth, he presses the little flower to his eyelids, never seeing Hermia asleep.

Oberon goes to Titania's bower and waits for her to fall asleep. He puts the juice of the flower on her

eyelids and instructs her to awaken when the first foul thing happens by.

Puck, on his way back to Oberon, finds a troupe of rustic actors. When Nick Bottom, the weaver, goes away from the group to practice on his own, Puck turns his head into an ass's head. Unaware of his transfiguration, Bottom comes back to his company who know enchantment when they see it. They flee in panic. Bottom thinks they're playing a joke and decides to sing to prove that he's not afraid. Titania hears him, awakens and falls in love. Puck returns with the news that Titania is in love with an ass. Oberon is delighted.

Demetrius finally succeeds in getting away from Helena. She wanders forlornly through the dark, eventually discovering Lysander whom she awakens. Lysan-

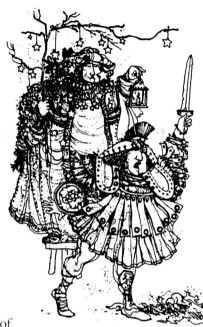

der, his eyelids mistakenly enchanted by Puck, sees Helena and falls in love. He chases her through the forest protesting his passion (and leaving poor Hermia alone). As they pass him, Oberon realizes the error and sends Puck to find Demetrius.

Lysander continues to follow Helena. Helena thinks it's all pretense to punish her for having told Demetrius about their planned escape. The enchanted Lysander swears his love to Helena, even weeping in his effort to prove sincerity. The more he protests, however, the more Helena thinks it's a cruel game.

Hermia wakes up and goes in search of Lysander only to find him courting Helena. Lysander callously tells her he hates her and loves Helena. Hermia bursts into tears and Helena thinks they're both tormenting her.

Finally, Puck has found the now-sleeping Demetrius, brushed the juice of the little flower across his eyelids and he awakens as Helena storms by pursued by Lysander who is pursued by Hermia. Demetrius attempts to court Helena who is now convinced they're all in a plot to torture her and flees with the lot of them following like hounds after a hare. The two young men grow incensed with each other, Hermia attempts to scratch Helena's face and Oberon shakes his head in disapproval at Puck, who has only made things worse.

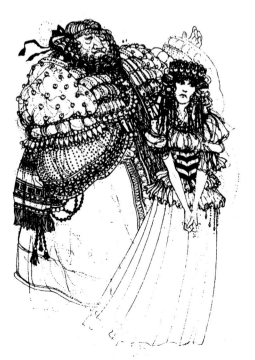

Oberon tires of the game he is playing on his queen and when she and her new beloved donkey fall asleep, Oberon applies to her eyelids the antidote that will end the enchantment. When she awakens, she tells Oberon that she has dreamed she fell in love with an ass, then discovers the dream was true. The faerie couple end their quarrel, and Oberon returns Bottom to his old rustic self.

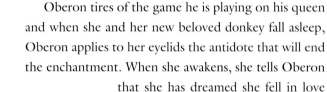

Oberon sends Puck to sort out the trouble he has caused with the two young couples. Puck confuses the wrangling lovers with a thick fog so they cannot injure each other and, by imitating their voices, brings them all to a leafy place where they fall asleep. Puck uses the antidote on Lysander to break his enchantment so he will return to loving Hermia, then leaves them sleeping.

In the morning, Theseus, Hippolyta and Egeus discover the two couples. Lysander admits that he and Hermia were attempting to escape Athens. Egeus insists that they be punished, but Demetrius declares his love for Helena, and Theseus overrules Egeus and commands that all three couples will be wed together.

In the town, the tradesmen actors are still grieving that they will not be able to perform for the duke without their friend Bottom, when he suddenly returns from the forest. Nick Bottom cannot explain the strange night he has spent and decides that the best thing will be not to try.

The three couples marry and, as part of the marriage revels, watch as the country players perform their laughable rendition of Pyramus and Thisbe. At the end of the evening, the couples retire and Oberon commands that the faeries bless the marriages. Puck closes the play by coming forward to stand between the dream and the waking world:

If we shadows have offended,
Think but this and all is mended:
that you have but slumbered here
while these visions did appear.
And this weak and idle theme,
No more yielding but a dream,
Gentles do not reprehend.
If you pardon, we will mend.
And, as I am an honest Puck,
If we have unearnéd luck
Now to 'scape the serpent's tongue,
We will make amends ere long.
Else the Puck a liar call.
So good night unto you all,
Give me your hands, if we be friends,
And Robin shall restore amends.

MUCH ADO ABOUT NOTHING

This play was long known as "Beatrice and Benedick." Though their love relationship may seem like a subplot, these are the characters that make the greatest transformation, and their wit is so much fun to watch. Of course, it's obvious to everyone that Beatrice and Benedick are in love from the start. They are simply too proud and afraid of scorn to admit it. The whole of the play revolves around the breaking down of their witty barriers so that they can enjoy the passion and delight that is possible between them.

A messenger brings news to Leonato, Messina's governor, whom Don Pedro, the prince of Aragon, will visit. Leonato asks how many men have been killed in the recent war. The messenger says very few. He praises the honor in battle of Claudio, a young Florentine. Leonato's niece Beatrice asks about Benedick. Hearing that he is alive, she begins to bait the messenger and insult Benedick. Leonato tells the confused messenger not to try to play at words with Beatrice. She is merely warming up for her next contest of wits with Benedick.

The prince arrives with his half-brother (the bastard Don John), Count Claudio and Benedick. Leonato invites them all to stay. Benedick and Beatrice immediately begin a lively repartee, to the amusement of the others. Later, Claudio tells Benedick that he has fallen in love with Hero, Leonato's daughter. Benedick rails against love and marriage. Don Pedro returns and Benedick tells him that Claudio is in love. The prince offers to help by wooing Hero on Claudio's behalf.

A servant overhears the conversation and reports it to Leonato, who then instructs his daughter, Hero, to accept the prince's proposal. Beatrice has a few choice words about men and love after which Leonato says they'll never find *her* a husband if she goes on that way.

Don John carps at his servant Conrade about being back in his brother's service. Conrade warns him to be careful. Don John says he may not be "a flattering, honest man" but he is a "plain-dealing villain." Don John, Conrade and another servant, Borachio, set out for the evening's entertainment to see what devilry they can cause.

At the evening's masked revelries, Beatrice and Benedick seek each other out and, in disguise claiming to be other people, insult each other. The prince woos and wins Hero for Claudio, but before he can convey the happy news, Don John and his allies tell Claudio that the Prince himself is planning to marry Hero. Claudio storms off.

Beatrice finally convinces Claudio to rejoin the party, at which time the prince tells him that he has made the match between Hero and Claudio which has Leonato's blessing. After Beatrice and Benedick go their separate ways to avoid each other, the prince engages Leonato, Claudio, Hero and her gentlewomen in tricking Beatrice and Benedick into admitting their love for each other.

Learning of the engagement between Hero and Claudio, Don John is bitter. (Don John is evil without motive, like other Shakespearean bastard characters.) His ingratiating servant Borachio tells him that he can make sport of breaking up this wedding.

The following day, the prince, Leonato and Claudio talk among themselves about how Beatrice is in love with Benedick, knowing that he is eavesdropping nearby. They say they will not tell him of it because they're afraid he'll scorn her. Benedick is stunned but decides that her love must be requited. At the same time, Hero and her gentlewomen, Ursula and Margaret, play the same trick on Beatrice, letting her overhear them talk about Benedick's being in love with her. Hero says that she will counsel Benedick to fight

BEATRICE:
I had rather hear my dog bark at a crow than a man swear he loves me.

BENEDICK:
God keep your ladyship still in that mind! so some gentleman or other shall 'scape a predestinate scratched face.

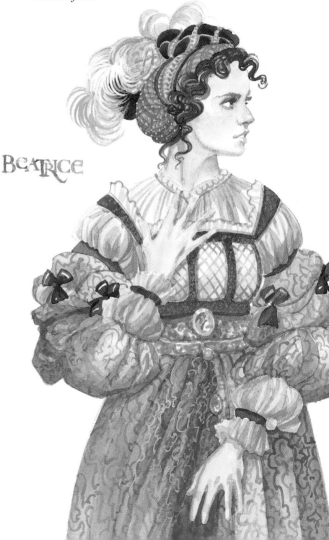

BEATRICE

BEATRICE:
*Scratching could not make it worse, an 'twere such
a face as yours were.*

—Much Ado about Nothing, Act I, Scene 1

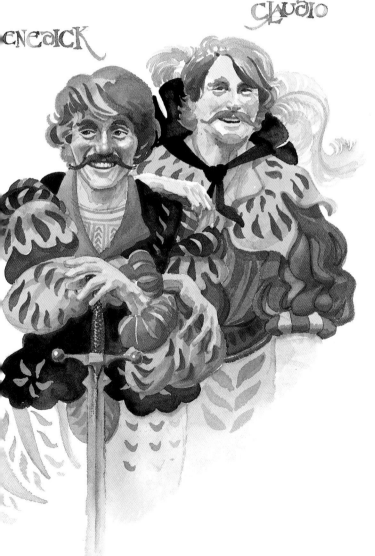

against his passion because Beatrice thinks more highly of her wit than of love. Beatrice, hearing herself thus described, decides she will change her ways.

The evening before the wedding of Hero and Claudio, Don John goes to the prince and Claudio to tell them that Hero has been unfaithful. Borachio has persuaded Margaret to stand in the shadows of Hero's bedroom window and address Borachio as her lover. The prince and Claudio watch from below, believing Margaret *is* Hero making love to Borachio.

In the town, the night watchmen assemble, instructed by Constable Dogberry and his neighbor Verges. In Dogberry, Shakespeare has created an inimitable comic policeman whose instructions to his men are full of malaprops and mistakes. Dogberry tells them to make no noise in the streets and they say they would rather sleep than talk. He agrees to this, saying he doesn't know how sleeping could offend. After he leaves, Borachio and Conrade appear, discussing the plot to disgrace Hero. The watchmen don't know exactly what they're hearing, but they recognize it as villainy. They capture the two men and hold them.

The following morning, Dogberry and Verges attempt to tell Leonato about the prisoners, but they are unintelligible and Leonato is late for the wedding. He sends them off with instructions to get the sexton to examine the prisoners.

At the wedding, Claudio refuses to marry Hero. He tells the assembled guests that she is no maid, that he

has seen her in her bedroom window with another man who, when confronted confessed to meeting her many times in secret. Hero faints and Claudio, the prince and his brother Don John leave, but Benedick remains behind. Leonato tells Hero that she has disgraced their family and is as dead to him. Beatrice defends her, saying that, until the previous night, she shared a bedroom with Hero.

The priest counsels that Hero should be kept hidden until the truth can be ascertained, and that he will tell everyone that Hero has died upon hearing the slander. Everyone leaves except Beatrice and Benedick. They declare their love for each other, and Beatrice asks Benedick to challenge Claudio to a duel in defense of Hero's honor. He refuses and she tells him that he must not really love her if he won't challenge her enemies. Eventually, Benedick agrees.

Dogberry tries to interrogate the prisoners but is comically obtuse. Finally, the sexton instructs the watch to accuse the men, and the story comes out. Hero is dead, he says, and Don John has escaped. The prisoners are brought to Leonato for the unveiling of the truth. Dogberry is still too unintelligible to present the case, so the prince demands that the prisoners tell their story. Borachio tells them that, urged on by Don John, he has deceived them. The prince and Claudio had seen *him* court *Margaret* in Hero's window. Leonato is inclined to think Margaret is at fault as well as Borachio, but Borachio swears that she knew nothing of what he

was doing. Claudio is stricken with remorse and begs forgiveness. He says he will do whatever penance Leonato demands. Leonato says Hero will be buried that night and Claudio should make her a public epitaph. He also tells him that his brother has a daughter and if Claudio will marry her the next day, then all will be forgiven.

Claudio keeps his promise at the burial ceremony. He proclaims Hero's innocence and commits to an annual ceremony in her honor. In the morning, Benedick asks permission of Leonato to marry Beatrice at the wedding ceremony of Claudio and Hero's cousin. Leonato instructs all the gentlewomen, including Hero and Beatrice, to put on veils. Claudio arrives and asks which lady he is to marry. Hero comes forward, still veiled, and Claudio asks her to reveal her face. Leonato says Claudio cannot see her until he agrees to marry her. He agrees to this, and she lifts her veil. The assemblage is astounded, but Leonato says that she died only as long as her slander lived.

Benedick then asks Beatrice to come forward. She does so and he asks if she loves him. She says no and asks if he loves her. He says no. Unable to say that they love each other, they prepare to part, when Claudio reveals a sonnet written by Benedick for Beatrice, and Hero offers a poem written by Beatrice about him. Revealed at last, they agree to marry. When a messenger enters, telling of Don John's capture, Benedick advises the prince not to worry about his punishment until the morrow.

What a Character!

O ne of Shakespeare's finest accomplishments was the creation
of characters that amuse and enlighten audiences, yet don't
advance the story line. The melancholy Jaques from As You
Like It, *the stuffy Malvolio from* Twelfth Night *and the circumlocu-
tory Don Armado from* Love's Labour's Lost *add savor with their
own peculiar viewpoints and antics.*

*At first, the perennially downcast Jaques (recall that Shakespeare
loved picking on the French, so this name is pronounced JOCK-wez)
isn't such a contrast from the separated lovers and unreconciled
brothers. But as the play progresses, love blooms, and forgiveness
begets harmony, Jaques, the only character to remain un-
changed, is a sour note in the merriment. He cannot go
back to court with Duke Senior, because he alone of all
the players has not been transformed.*

*The grandiloquence of Don Armado (a silly
Spaniard whose name is suspiciously similar to the
late and unlamented Armada) is a veritable ban-
quet of sonorous sesquipedalian bombast. Better still,
he falls in love with Jaquenetta, a country girl who
cannot even read, much less decipher the flatulent
hyperbole he writes to her.*

*Malvolio (a name that means "ill will") has the
temerity to aspire to marry the lady for whom he is
a steward. The more liberal characters that he pre-
viously scolded play a joke on him to make him be-
lieve he might succeed with Lady Olivia. For his
pains, he winds up locked in a dark room as a lu-
natic and is freed only when the prank is exposed.
This may seem excessive, but the customs for mar-
riage were very strict. Malvolio, a commoner who desired a
noble lady, broke the rules and was therefore brought low.*

JAQUES

THE TAMING OF THE SHREW

Whether you think *The Taming of the Shrew* is a sexy romantic comedy or a scary taste of patriarchal fascism, someone, somewhere, has done a production that will support your particular viewpoint. If you've never seen the complete play (many movie versions shorten the text) it begins with an "induction." This could be a misspelling, but many people are induced to one thing and another, so it could just as well be Will having a little fun with language.

The induction shows an aristocrat having a little fun with the drunkard Christopher Sly. The lord takes the drunken man home, surrounds him with luxury and tries to convince him that he's actually an aristocrat himself and has been suffering from a madness that makes him *think* he's poor. A group of players comes in and performs *The Taming of the Shrew*. After a couple of references to Christopher Sly, the play becomes the thing and we never find out what happens with the "inducted" aristocrat.

Of course, what subplot could compete with Kate's tantrums? Katharina is unlucky enough to have a "perfect" sister. Bianca is younger and milder. Men like her better, and she's the kind of sibling who makes parents say, "Why can't you be more like your sister?" Notwithstanding her reputation as a sweet young thing, Bianca gets her little digs in at Kate when they're alone. Lucentio and Hortensio each want to court Bianca, but the girls' father, Baptista, refuses to let Bianca marry until the older sister, Kate, is wed.

The young men resort to all sorts of disguises and ruses to get themselves into Bianca's presence. Lucentio sends his servant Tranio disguised as himself to conduct the business of marriage while he, disguised as a scholar, gets himself presented as her new language teacher. Hortensio gets in as a music teacher, and gets a lute broken over his head by Kate for his pains.

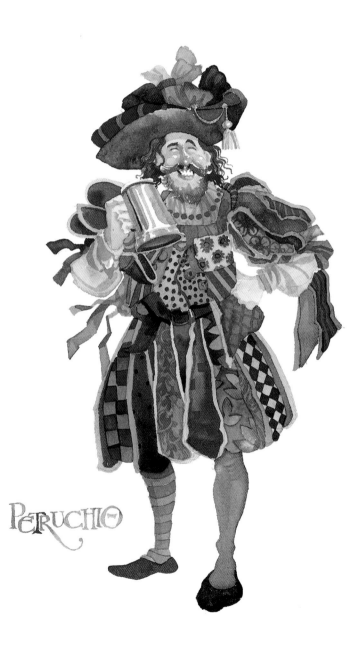

PETRUCHIO

Enter Petruchio. He's in the market for a wife. He wants one with a dowry and he's not afraid of shrews. He ignores Kate's insults and tantrums, and she finds herself married and on her way to his house in no time at all. Petruchio's strategy is simple: he acts just like Kate has. He beats his servants for the bad food and dismisses tailors because the clothing they make isn't good enough for her. Poor Kate gets no meat nor drink nor sleep until she gives in.

Meanwhile Baptista has auctioned off Bianca. Tranio, disguised as Lucentio, gets someone to stand in as his father, who has a big fortune, so "Lucentio" gets permission to marry her. The true Lucentio, disguised as the language teacher, elopes with Bianca, but all is well once his real father shows up and everybody returns to their original selves. Hortensio marries a wealthy widow. Petruchio and the tamed Kate attend the double wedding, where Kate shows herself to be a more dutiful wife than Bianca or the widow.

An Elizabethan Almanac, Sort Of

When characters in any of the plays mention the term "country matters," they aren't referring to horticulture, viticulture, raising chickens, making cheese, pruning trees or the market price of mangels. Everyone in the audience knew that once country matters were mentioned, the subject was sex. Not love, not romance, but sex.

THE COMEDY OF ERRORS

You'll need to suspend your disbelief from a bungee cord for this play. Not one, but *two* sets of infant twins—one wellborn, the other serving class—were separated in storms at sea. Worse still, each parent or guardian thinks he or she has the same twin. Imagine it this way: one set of twins were named Bill and Bob. Mom thinks she has Bill. Dad thinks *he* has Bill. They both think Bob's probably dead. And then the very same thing happens with the parents of the other set of twins. So we have wellborn Antipholus of Syracuse as well as Antipholus of Ephesus, and servant-class Dromio of Syracuse as well as Dromio of Ephesus. And if your imaginary bungee cord will stretch a bit further, the two serving-class twins are serving the two wellborn twins.

When he turns eighteen, Antipholus of Syracuse takes his servant Dromio and goes looking for his long-lost brother. When his father has had no news from him for a long time, he goes off looking for his son, or his wife and other son. Unfortunately he's imprisoned in Ephesus because he's from the enemy state of Syracuse, and he's under threat of death unless he can pay a huge ransom.

You can see most of the plot from miles away. First, Antipholus of Ephesus and Antipholus of Syracuse run into the wrong servants, Dromio of Syracuse and Dromio of Ephesus. Each thinks the other is crazy or up to some knavery. Dromio of Ephesus takes Antipholus of Syracuse to the house of Antipholus of Ephesus, where he falls in love with the sister (Luciana) of his brother's wife (Adriana). Luciana thinks he is her sister's husband. (Keeping up so far?) The right Antipholus tries to get into his house and is refused.

A gold chain made for Antipholus of Ephesus is given to Antipholus of Syracuse. Later the merchants want the money for the chain and take an officer to Antipholus of Ephesus and arrest him. He meets Egeon, who is really his father, but since he doesn't know him, he repudiates the old man. Finally the Syracusans hie themselves to a priory for sanctuary. The prioress turns out to be Emilia, the long-lost wife of Egeon, who puts everything together and explains the situation. The two Antipholuses end up with the right ladies, and everyone goes to a feast in the priory.

The first thing we do, let's kill all the lawyers,* & Other Lines We Still Use

He hath eaten me out of house and home.
—II Henry IV, Act II, Scene 1

This denoted a foregone conclusion.
—Othello, Act III, Scene 3

I'll not budge an inch.
—The Taming of the Shrew, Induction, Scene 1

I must be cruel, only to be kind.
—Hamlet, Act III, Scene 4

True it is that we have seen better days.
—As You Like It, Act II, Scene 7

They'll give him death by inches.
—Coriolanus, Act V, Scene 4

If I do not leave you all dead as a doornail...
—II Henry VI, Act IV, Scene 10

Give the devil his due . . .
—I Henry IV, Act I, Scene 2

The better part of valor is discretion.
—I Henry IV, Act V, Scene 4

Let's make the best of it.
—Coriolanus, Act V, Scene 6

We have heard the chimes at midnight, Master Shallow.
—II Henry IV, Act III, Scene 2

Both of you are birds of selfsame feather.
—III Henry VI, Act III, Scene 3

Let Hercules do what he may, The cat will mew and dog have his day.
—Hamlet, Act V, Scene 1

Once more into the breach, dear friends...
—Henry V, Act III, Scene 1

Upon familiarity will grow more contempt.
—The Merry Wives of Windsor, Act I, Scene 1

We are as true as flesh and blood can be.
—Love's Labour's Lost, Act IV, Scene 3

The game is up.
—Cymbeline, Act III, Scene 3

Can one desire too much of a good thing?
—As You Like It, Act IV, Scene 1

*II Henry VI, Act IV, Scene 2

LOVE'S LABOUR'S LOST

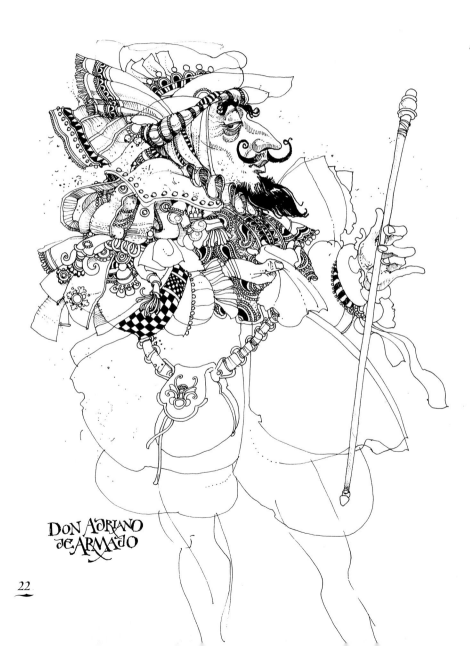

DON ADRIANO DE ARMADO

Young men can be complete idiots, even if they are kings and courtiers. The king of Navarre, in pursuit of some ascetic ideal, has decreed that for three years he and his court will practice a strict diet of no girls, no banquets and no revelry. They intend to study and improve their minds (well, there's no denying they need that).

Two of the king's gentlemen, Longaville and Dumain, sign right up, but Berowne is more cautious. He knows he likes girls and parties and has sense enough to know that they haven't injured his wits thus far. But he eventually signs the promise as well.

You'll notice throughout this play that there are many in-jokes and obscure references. Ignore them. Even scholars aren't sure what all of them mean, and their main importance is to play up the over-the-top quality of excessive manners. Don Armado, a Spaniard in the king's court, is a loquaciously indecipherable example of courtly posturing. What better destiny, then, that he fall in love with a country wench who cannot even read the lush verbosity he writes to her? (Illiteracy was no impediment. We hear at play's end that he has made her pregnant; *amor vincit omnia!*)

Once the four young men have signed up for three years' rigorous abstinence, it is inevitable that four

young ladies will appear, so the princess of France and three of her gentlewomen come to the court and the young men promptly fall in love. Berowne is the first to succumb. He writes a letter to Rosaline, but an inept servant delivers his letter to the peasant girl Jaquenetta and gives Armado's letter to Rosaline, and the ladies read it with glee.

Shortly, Berowne overhears the king confess his love for the princess. The king hides and hears Longaville confess love for Maria, and then Longaville hides as Dumain comes in and confesses love for Katharine. Longaville steps out and mocks Dumain for breaking the vow, the king steps out and mocks Longaville, and Berowne steps forward and chides the king. Just as Berowne implies that he alone has kept the vow, Jaquenetta brings in the letter he wrote to Rosaline.

With their desires unmasked, the young men decide to visit the ladies. They dress up as Russians, and each gives a love token to the lady of his choice. Seeing through their disguises, the ladies later exchange tokens and meet the gentlemen masked while wearing the wrong token, which leads each gentleman to declare his passion to the wrong lady.

They're in the process of setting it all right when a messenger brings news that the king of France has died. The gaiety ends and the ladies prepare to depart. The princess tells the king that she will listen to his suit in a year's time, if he will promise to live a reclusive life for a year. The other ladies make like demands. Rosaline commands the witty Berowne to spend the year in a hospital making dying people merry. The labors of love are lost for the moment, but one knows that all will be well when the year has ended.

Elizabethan Culture

Imagine a world without cars, electricity, toothpaste, the Internet, air travel, movies, frozen orange juice, stereos, ice cream, cappucino or overnight shipping. Think of it: no television, no drive-through restaurants and no credit cards. Sounds grim, doesn't it?

Actually the folks in Shakespeare's day probably thought they were living pretty well. The world had survived the Black Plague of the 1300s. The death of about one third of Europe's population had the unexpected benefit of creating a labor shortage and breaking the back of the old feudal system, which led to more movement in the population. The widened horizons led to greater knowledge and fueled a dynamic cultural metamorphosis that we now know as the Renaissance.

Wonderful works of art, drama and literature were created. With the invention of the printing press, there was a spread of new knowledge that even surpasses our experience with the Internet. With the advent of printing and books, literacy became more the norm, at least amongst the noble and moneyed classes. Classical works from Greece and Rome were rediscovered and translated. Ideas from these texts led to the rise of humanism, which in turn meant a more secular view of both day-to-day life and government.

The Renaissance came to its finest flower in England during the reign of Elizabeth I, who was crowned in 1558. Her time as regent saw a codification of the Anglican re-ligion and a further distancing from the powers of the Roman Church. Elizabeth ruled the country (and did a very good job) until her death in 1603 at the age of seventy. During her reign, England was largely peaceful, and with peace came prosperity.

There was a virtual explosion of wealth in the merchant class. Traders, shopkeepers and the like changed the economy. Wealth no longer began just at the top with nobles and princes. And money, as in our own time, has a way of breaking down class barriers. But not all barriers came down. Dark-skinned people, like the Moors from Africa, were seen as incapable of learning and good sense. People of other religions were never given the same rights as Christians, and women were, for the most part, still considered to be possessions of the family.

Life was still basically built on Christian hierarchy; life may have become more secular in that the Church was no longer a major political force, but no one questioned the rightness of Christianity. God oversaw the universe. The king ruled (by divine dispensation) the lives of his subjects. A man was bound to follow Christian law and a woman was bound to follow the rules of her husband.

The remarkable thing about Shakespeare is that while he was conservative in his views he was able to create characters like Othello, Shylock and the innumerable unconventional female characters that make his plays so pleasurable.

AS YOU LIKE IT

The tyrannical older brother, Oliver, denies Orlando, a young nobleman, his rightful inheritance. Orlando decides to try to win prize money by wrestling Charles, the duke's wrestler, who, we soon learn, has already injured three sons of another family so badly that they are not expected to live. Charles wants Oliver to persuade his brother Orlando not to wrestle lest Charles hurt or even kill him. Oliver, who would just love to see Orlando's neck broken, says that Orlando is a villain who will try to kill Charles. He instructs Charles to wrestle, not hold back, and if he kills Orlando, Oliver won't hold it against him.

At court the next day, Celia tries to cheer her cousin Rosalind. Duke Frederick, Celia's father, has usurped the dukedom and banished Rosalind's father, Duke Senior. Duke Frederick has kept Rosalind at court as a companion to his daughter. Rosalind, wise and loving despite hard times, puts on a smile for her cousin's sake. The court jester, Touchstone, arrives and entertains them. Then Monsieur Le Beau, a very silly and rather precious fellow, arrives

All the World's a Stage

All the world's a stage,
And all the men and women merely players:
They have their exits and their entrances;
And one man in his time plays many parts,
His acts being seven ages. At first the infant,
Mewling and puking in the nurse's arms.
And then the whining school-boy, with his satchel
And shining morning face, creeping like snail
Unwillingly to school. And then the lover,
Sighing like furnace, with a woeful ballad
Made to his mistress' eyebrow. Then a soldier,
Full of strange oaths and bearded like the pard,
Jealous in honour, sudden and quick in quarrel,
Seeking the bubble reputation
Even in the cannon's mouth. And then the justice,
In fair round belly with good capon lined,
With eyes severe and beard of formal cut,
Full of wise saws and modern instances;
And so he plays his part. The sixth age shifts
Into the lean and slipper'd pantaloon,
With spectacles on nose and pouch on side,
His youthful hose, well saved, a world too wide
For his shrunk shank; and his big manly voice,
Turning again toward childish treble, pipes
And whistles in his sound. Last scene of all,
That ends this strange eventful history,
Is second childishness and mere oblivion,
Sans teeth, sans eyes, sans taste, sans everything.

—Jaques, As You Like It, Act II, Scene 7

to tell the ladies of the wrestling match.

Accompanied by Touchstone, the ladies go to see the wrestling. Rosalind and Celia see Orlando waiting for his chance to wrestle. Alarmed at his youth, they try to dissuade him from the match. He begs them not to interfere, then wrestles with Charles and wins.

Duke Frederick is incensed when he discovers that Orlando is the son of the late Sir Rowland, who was a loyal supporter of Duke Frederick's banished brother. Rosalind, however, is smitten with young Orlando and makes him a present of her necklace. He is smitten as well but becomes tongue-tied in her presence. The ladies exit, and Monsieur Le Beau comes forward to tell Orlando that the Duke has taken against him and he'd better get out of Dodge. Orlando, who had hoped to win money for winning the wrestling match, is now faced with the prospect of going back to his brother's abuse, still penniless.

THE SEVEN STAGES

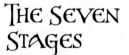

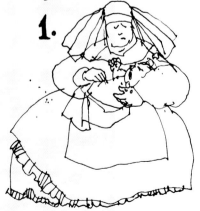

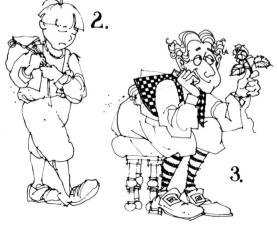

Duke Frederick is still stewing. He banishes Rosalind. Celia tries to plead her cousin's case, but the duke tells her that her cousin is held too high in the people's regard and that she herself will benefit from not having the competition. Celia must take after her mother because she doesn't buy this reasoning, and the two ladies secretly plan to leave.

Rosalind dresses as a boy, calling herself Ganymede. Celia dresses as a commoner and calls herself Aliena. They decide to go to the forest of Arden, where the banished Duke Senior (Rosalind's father) is living with his loyal followers. Touchstone agrees to go with them.

In the forest, Duke Senior looks with gusto on the bright side of country life. He and his fellows talk about the simple life, comparing the discomforts and joys of rustic living to the dangers at court. We are introduced to Jaques (which they pronounce *Jock*-wez) a gloomy fellow, always finding the cloud in a silver lin-ing. In the play, he serves as counterpoint to Rosalind's open willingness to enter life with all its pain and joy. Although Jaques lives among Duke Senior's exiled community, he is not a *part* of it. The Duke likes to tease him about his melancholy.

Back at court, Duke Frederick discovers that his daughter is missing and gets even angrier. He wants answers, by God. Finally one of Celia's ladies tells him she heard Rosalind talking about Orlando and they probably have gone to him.

Meanwhile, when Orlando returns home after wrestling, his sweet old servant, Adam, warns him that Oliver is planning to burn down Orlando's shack— with Orlando inside. Adam gives Orlando the money he has saved for his own old age and, in a touching gesture, follows his young master into banishment. When they finally make it to the forest, Adam faints from hunger and weariness. Orlando goes in search of food.

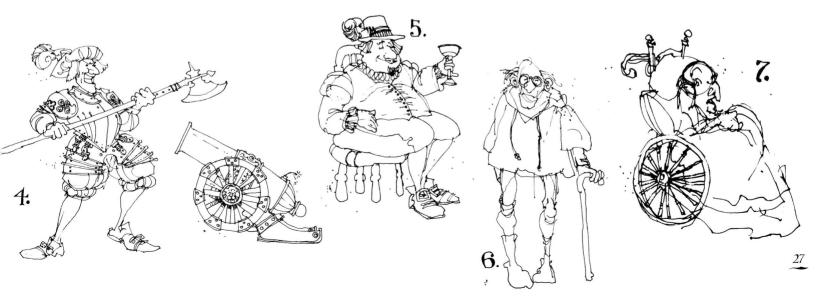

4.

5.

6.

7.

Rosalind (dressed as Ganymede), Celia and Touchstone arrive in another part of the forest, also exhausted and hungry. They purchase a cottage and a flock of sheep from a shepherd.

In *his* part of the forest, Duke Senior and his followers sit down to eat. As they're about to begin the meal, Orlando enters, sword drawn, demanding that they give him food. Duke Senior's reply is so gracious that Orlando, ashamed, puts away his sword. He had expected, he says, that everything in the forest would be wild and fierce. Otherwise, he would not have approached them so rudely. He goes away to fetch Adam.

Back in court, Duke Frederick, still frothing at the mouth over his daughter's flight, goes to Oliver, demanding Orlando. Oliver denies any knowledge of his brother's whereabouts. The duke, of course, doesn't believe him. It doesn't help Oliver's case when he says he never loved his brother. The duke has Oliver thrown out of his house. His lands and possessions are forfeited until he can produce his brother. Duke Frederick gives him a year (in pre-credit-bureau days, it took longer to find someone) to bring in his brother, or all Oliver's lands will be forfeit forever.

In the forest, the air is thick with romance. Orlando hangs love poems to Rosalind on trees. Rosalind sighs for Orlando, who she doesn't yet know is in the forest. Silvius, the shepherd, pursues Phebe, the shepherdess, who scorns him. When Rosalind (as Ganymede) sees Phebe scorn Silvius, she takes Phebe to task. Phebe falls in love with Ganymede, who then insults her. Touchstone courts the not-too-bright wench Audrey with more lust than love. At last Orlando and Ganymede meet, and Ganymede convinces Orlando to court him as if he were Rosalind, just for practice.

After courting Ganymede for many days, Orlando doesn't appear at his appointed time. Instead, Oliver arrives. Orlando has saved his life and was wounded by a lion. Celia, dressed as the commoner Aliena, falls in love with Oliver, and they agree to marry. Orlando cannot bear the pretend courtship any longer. Ganymede tells him he is a magician and will produce Rosalind if Orlando agrees to marry her. Ganymede then tells Phebe that he agrees to marry her tomorrow, unless Phebe doesn't want Ganymede. And if she refuses Ganymede, she must agree to marry Silvius. Phebe agrees.

Everyone assembles the next day in preparation for one of Shakespeare's multiple weddings. Ganymede, after securing promises from all parties to keep their words, leaves the company and comes back as Rosalind, accompanied by the god Hymen. Phebe can't marry Ganymede (unveiled as Rosalind) so she agrees to marry Silvius. The couples all marry and are blessed by Hymen. A messenger comes to Duke Senior to tell him that Duke Frederick had marched toward Arden forest to attack him. On the way, however, Frederick met a holy man and, after speaking with him, decided to become a monk (and why not, when nothing ever pleased him?) and has therefore returned to Duke Se-

nior his title and the urban court. The assemblage is generally merry, but for Jaques who declares that he will not go back to court with Duke Senior. He wants to find Frederick to learn what happened to him.

So the title *As You Like It* means what exactly? One of the play's grand themes is the pursuit of happiness in life and love. The characters represent the benefits of country vs. urban life evenly. For the exiled duke, a little wilderness sabbatical has renewed him for his return to the ambition of court life. And the pursuit of happiness in love, in Shakespeare at least, is usually to resolve the madness of romantic love, with marriage.

The Fool on the Playbill

The fool had a special place in the courts of the England's nobility. He was meant to engage the company with rhymes and jests. He might be found composing ad-libbed ditties about the foibles of guests, but he wasn't above a spot of flatulence to get a laugh.

Shakespeare took the idea of these wits at court and added his own spin. Shakespeare's fools are not foolish. They may prattle, but there's a point to the jest: a pithy assessment of another character, the bite of truth born out of badinage. The fool's persona allowed the audience to be part of the in-joke. And since he is not caught up in the love or lunacy around him, his perspective is one the audience can trust.

The most memorable fools appear in Twelfth Night and King Lear. Lear's fool (who has no other name) follows his master into the wilderness where the king's madness has taken him. The fool's obvious sanity and accurate observations make his loyalty all the more poignant, especially since it is possible (his part ends without explanation) that he dies of it.

Feste, the fool in Twelfth Night, is a more comical character. He carouses with Sir Toby Belch and Sir Andrew Aguecheek, participates in the practical joke on Malvolio and cheers the grieving Lady Olivia with his wit. Nonetheless, his songs and comments have a melancholy edge. He reminds the audience that time will pass and all things fade despite the magical landscape that seems made only for love and merriment.

Shakespeare's fools provide counterpoint. Where tragedy and madness reign, fools offer witty sanity, and where comedy and love hold sway, they remind us that pleasure is delightful but momentary.

TWELFTH NIGHT

In a seacoast kingdom named Illyria, Duke Orsino is in love with Lady Olivia but she is in seclusion, mourning her brother's death. Off the coast, a ship founders and twins, Sebastian and Viola, are separated. The captain pulls Viola to safety, but they believe Sebastian must have drowned. The captain tells Viola that Lady Olivia is in seclusion and will permit no intrusion, and the duke will have no women at his court. Viola has to get by somehow, so she dresses as a boy and joins the duke's entourage as a page named Cesario.

Olivia's uncle, Sir Toby Belch, brings the silly, cowardly Sir Andrew Aguecheek as her suitor. Toby and Andrew are upbraided by the steward, Malvolio, for carousing in Olivia's house. Maria, Olivia's chambermaid (who is in love with Toby, though one cannot fathom why), and Toby take revenge with a nasty practical joke. They drop a letter in Malvolio's path, supposedly from Olivia. The love letter asks Malvolio to act and dress absurdly. The vain Malvolio believes himself to be the object of Olivia's affections and capers about, flirting with Olivia until he's locked up as a lunatic.

Not far away, Sebastian has survived the shipwreck with the help of a companion on board, Antonio. Grieving for his sister, he decides to go to Illyria. When Sebastian departs for Orsino's court, Antonio follows him, but in disguise. (Antonio has fought against Illyria and would be in danger there.) They meet up, and Antonio loans his purse to Sebastian.

Duke Orsino goes on about Olivia while Cesario (Viola), who has fallen in love with him, listens in torment. Orsino never goes to make his suit in person but sends Cesario, who gains access to Olivia by refusing to leave the gate. Cesario charms Olivia, who in turn falls in love with "him." Seeing this, Andrew challenges Cesario to a duel. The reluctant fighters begin. Antonio shows up and, seeing who he believes is Sebastian beset, takes over the fight. Sir Toby takes Sir Andrew's sword. Orsino's soldiers arrive and arrest Anto-

MALVOLIO

nio, who asks Cesario to return his purse. Cesario is confused. Antonio thinks he has been betrayed. He is held in chains to await the duke.

One of Olivia's servants sees Sebastian, thinks he is Cesario and takes him to Olivia's house. Sir Andrew assaults him. Sebastian strikes back, then draws his sword. Sir Toby again takes over the fight. Olivia dashes out and scolds Toby. When Olivia, a beautiful and obviously rich woman, says she wants to marry him, Sebastian says yes and they trade vows, even though he wonders if she and everyone else might be mad.

Olivia goes to meet Duke Orsino, who has arrived with Cesario to collect Antonio. Orsino asks Olivia to marry him. She refuses. When the duke's group withdraws, Olivia calls Cesario "husband," which surprises everyone, especially Cesario. Toby and Andrew enter, bruised. They accuse Cesario of continually fighting. Sebastian arrives, all is explained and Viola is "unmanned." Orsino discovers that the page he has become so fond of is a lady and decides to marry her. He also pardons Antonio. Malvolio is set free, and Sir Toby's plot is revealed. As thanks for her help, Sir Toby marries Maria. Malvolio and Antonio are left unwed (but Antonio is in love with Sebastian, who's already taken). The two royal couples celebrate their weddings together.

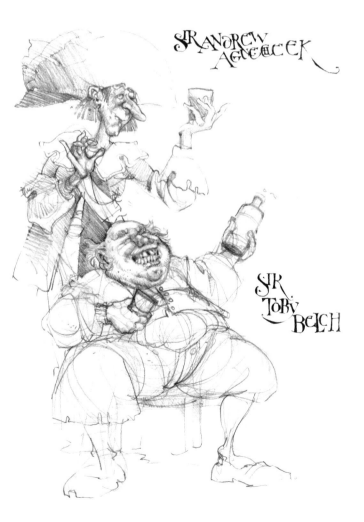

SIR ANDREW AGUECHEEK

SIR TOBY BELCH

VIOLA AS CESARIO

THE MERRY WIVES OF WINDSOR

There is a theater legend that says Queen Elizabeth I was so taken with the character of Sir John Falstaff, originally from *Henry IV*, that she commanded Shakespeare to include the rascally knight in a future play. If this story is true, Shakespeare outdid himself to please the queen. The play is hilarious, has no real low moments at all and tumbles from one riotous scene to the next with barely a pause.

Sir John Falstaff finds himself out of pocket. He instructs one of his servants, Bardolph, to go to work for the tavern keeper and more or less jettisons his fellows Pistol and Nym, who are really peeved about this treatment. Falstaff writes to Mistress Ford and Mistress Page, professing passion in hopes of getting money from one or both. Unfortunately, he writes the same letter to both, and they show each other the letters. They decide to get even with him.

Pistol and Nym report to Mr. Page and Mr. Ford that Falstaff is wooing their wives. Mr. Page is confident of his wife and says Falstaff is unlikely to get any-

thing from her except scolding. Mr. Ford, however, is jealous and decides to dress up as a Mr. Brook and get Falstaff to woo Mistress Ford on Mr. Brook's behalf. He pays Falstaff money to get him to tell Mr. Brook when Falstaff will be alone with Mistress Ford.

The Pages have a daughter, Anne, who is of marrying age. Mr. Page wants the anemic Slender to marry her, while Mrs. Page prefers the pedantic Dr. Caius. Anne has already found the right suitor, Fenton, who is an aristocrat but not well-off. Mr. Page thinks he's courting Anne only because of her money.

Mistress Page and Mistress Ford lay their plan. Mistress Ford sends a message to Falstaff to come to her house when her husband isn't home. Falstaff tells Mr. Brook that he's going to woo Mistress Ford. When Falstaff arrives at Mistress Ford's house, Mistress Page rushes in and tells Falstaff and Mistress Ford that Mr. Ford is coming with companions. The ladies hide Falstaff in the linen basket and send it out to be dumped in the river. Mr. Ford is intending to find his wife cheating and finds nothing. Mr. Page takes him to task.

The ladies continue their pranks on Falstaff but eventually tell their husbands. Mr. Ford realizes he's been a fool. In one final prank, the Mistresses convince Falstaff to wear horns and chain himself to a tree as a magic rite. They dress the village children as faeries and torment poor Falstaff.

Anne's parents attempt to get her married to the suitor each has chosen, but Anne slips away with Fenton, and the other two suitors find they've tried to marry village boys disguised in white and green dresses. All ends happily, and even Falstaff is invited home for dinner and reveling.

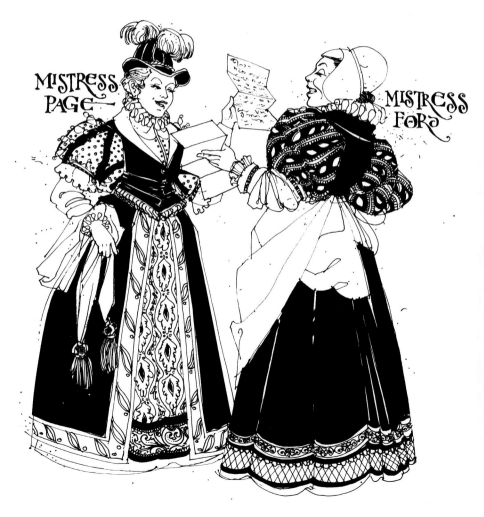

MISTRESS PAGE

MISTRESS FORD

Plays Nobody Ever Goes To See Because They Aren't That Interesting

There are a few plays that are rarely performed because a play isn't really a play unless there's an audience. During the Elizabethan era, most folks, high and low alike, knew a lot about their country's history, so a play like King John or Henry VIII could make a profit. Not so today. When these plays are performed today, it's often because an acting group decides to do all the plays. ❦

TWO GENTLEMEN OF VERONA

Critics, scholars and the viewing public alike have long been underwhelmed by this play. Proteus and Valentine have been friends a long time, but Proteus has fallen for Julia and is wallowing in melancholy. Valentine is bound for the court of the Duke of Milan. He tries to tease his friend out of his mood, but finally leaves. Proteus's father decides Proteus needs to go to Milan as well, so off he goes, pining the worse for leaving Julia behind.

Launce, Proteus's manservant, departs as well, bemoaning the indifference of his dog, Crab. Although the other characters are fairly stock roles, Launce is a glimmer of the Shakespearean clowns to come, and he's more fun to watch by miles than his master.

In Milan, Valentine has fallen for Silvia, the duke's daughter whom the duke is planning to marry to Thurio. Valentine compares Silvia to Julia, telling Proteus that Julia is fit to carry Silvia's train. So what this says

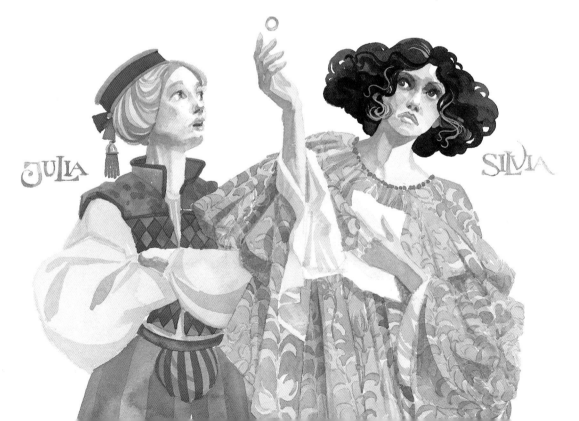

JULIA

SILVIA

to Proteus is "my girl's better than your girl, and that makes me better than you." Proteus decides to trade up and woos Silvia (unsuccessfully) behind his friend's back and then betrays his friend to the duke, who banishes Valentine.

Julia dresses as a boy, becomes Proteus's page, discovers his love for Silvia but doesn't give up on him. Everyone ends up in the forest, where Proteus tries to ravish Silvia. Valentine prevents him.

Proteus begs forgiveness, so Valentine tries to give Silvia to him. Julia, dressed as the page, has the sense to faint. She's revealed as Julia, Proteus falls in love with her again and they all live happily ever after.

Greatest Non-Speaking Role

Crab, the dog, never tells us a thing about himself, but his master, Launce, from Two Gentlemen of Verona, *gives us plenty of information about his pet's personality and rather more detail than one could want about his socially unacceptable toilet habits.*

THE PROBLEM PLAYS
AND OTHER PROBLEMS

The so-named problem plays were probably not a problem for William Shakespeare, who was merely working his way toward maturity as a playwright. For his audiences, however, some of the situations were too realistically gritty for entertainment. We can imagine early theatergoers shaking their heads as they left the theater. "I'll wager he finds a way to get rid of her in a year," or "She'll poison him when she discovers his true nature." There was altogether too much pre- and extramarital sex for nice people, especially during the Victorian era. "Good gracious, you can find social realism in any common alleyway, if you are inclined to look. One goes to the theater, dear, for something a little more elevating."

The problem plays are *All's Well That Ends Well*, *Troilus and Cressida* and *Measure for Measure*. Scholars also have a problem with these problem plays because they don't fit neatly into a category. As comedies, they are too dark. The social realism of the events lends an air of ambivalence or even gloom to the "happy" endings. But these plays aren't tragedies either. There are no great men with disastrous flaws that lead to their downfall, and somebody always gets married at the end. They possess none of the subtle ethereality and beauty of the romances. Their ambiguity gives the learnéd stomachaches.

In the past, the problem plays have often been swept under the carpet. Thanks to modern media, our delicate sensitivities are not such a concern today. Other forms of public entertainment have inured us to sex and violence. Today, we may not have so many problems with the problem plays, but we have new problems with other plays. We have become more tolerant and open about sex, and different religions, and more open to the equality of the sexes, all of which

means that our new-found tolerance makes us intolerant of earlier intolerances.

The forced conversion of Shylock, for example, in *The Merchant of Venice* has more shock value than MTV. It's not necessarily that we believe that people of faiths different from our own are right. We just prefer that their civil rights be left intact. If they choose to go to Hell, that's their business. Those of us who lived through the women's movement gnash our teeth at *The Taming of the Shrew*. Kate sounds more like a victim of the Stockholm Syndrome, where the captive comes to sympathize with the captor, than a woman who has discovered her ability to love by letting go of her vile temper. And even guys with tattoos and loud motorcycles might be hesitant to let their daughters date a fellow like Petruchio.

In sum: other times, other problems. The problem plays are interesting for their brush with realism that puts Shakespeare ahead of his time. The open treatment of vice without subsequent terrible punishment wasn't often seen in fictional works until the twentieth century.

TROILUS AND CRESSIDA

Troilus and Cressida takes place during the Trojan War. In case you've forgotten the *Iliad* from high school, the Trojan War started when Paris, a Trojan prince, stole Helen from her Greek husband, Menelaus. The play begins after the war has started and ends before the Greeks come up with the wooden horse ploy, so even though the Trojan Hector is killed, there is no real sense of conclusion.

As the play begins, Troilus bemoans how his love for Cressida keeps him from fighting. (Already we're thinking, "What a wuss.") Cressida's uncle, Pandarus, has to

I'm Shocked, Mr. Shakespeare, Shocked!

———✧———

Every generation has issues they'd just as soon sweep under the rug, like prostitution, extra- or premarital sex, bawdy jokes and the like. Thomas Bowdler was so put off by Shakespeare's naughty stuff that he wrote a ten-volume set eliminating or sanitizing everything he found objectionable. By all accounts, this family-friendly rewrite was very popular. Apparently a couple of the plays were so full of not-fit-for-ladies stuff that Bowdler published them with warnings. Imagine the fun he'd have had with today's rap lyrics.

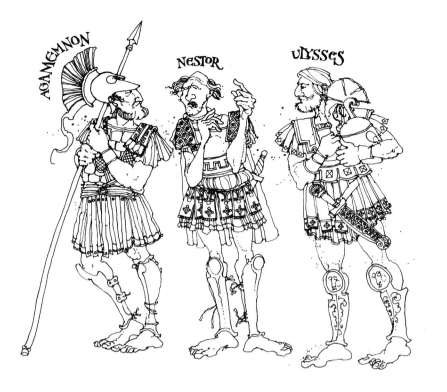

AGAMEMNON NESTOR ULYSSES

speak for Cressida, since her father, Calchas, has deserted to the Greeks (way to go, Dad). A Trojan warrior shames Troilus into joining the fighting. Pandarus goes to Cressida and talks up Troilus, while they watch the battle from a window. After he leaves, Cressida refers to him as a "procurer" but admits to herself that she likes Troilus.

Back at the Greek encampment, the commander tells his troops that the war continues because Jove is testing them. Ulysses isn't sure. He has many words to say to the Greek warriors. They aren't respecting their elders and betters, which is why the world is in the shape it's in, etc. He has heard Achilles and Patroclus aping (and insulting) their superiors, etc. Nestor pipes up that Ajax and his fool, Thersites, do the same.

Actually, Thersites is with his boss, Ajax, insulting *him*. Unable to win a war of wits, Ajax smacks him around. Thersites makes this play worth seeing for his wit and invectives, born of his own lost idealism.

The Trojans are also pretty tired of battle. Hector, who sounds sensible (but wait to cast your vote), thinks they should send Helen back. Then everybody could go home and put their feet up. Troilus and Paris argue in favor of keeping Helen. They reason that since they've already fought over Helen, they have to keep fighting over Helen in order to maintain their honor.

After a long day's fighting by other people, Pandarus brings Cressida to Troilus. The rhetoric is high and romantic, but basically they're there to romp through Cupid's grove, and they do.

Elsewhere, Cressida's father has made plans to trade her for the captured Trojan, Antenor. (He hasn't much to do with this play, but as the guy who eventually betrays Troy, he's a nice ironic touch.) Calchas sends the Greek warrior Diomedes to make the trade. Shortly, Cressida ends up in flagrante with Diomedes, in a little scene which Troilus, Ulysses and Thersites watch.

Diomedes also ends up stealing Troilus's horse, which is the only thing Troilus seems to remember when he later confronts Diomedes in battle, though this may have been a bawdy reference to him losing his "mount." During the battle, Hector kills a warrior in beautiful armor and decides (now you can vote on how sensible he is) to take off his armor and put on the cool

stuff. Of course, Achilles' henchmen, the Mrymidons, come in and stab him between the plates of armor. Although Hector is dead, the Trojans continue to fight and the war goes on. Pandarus provides the epilogue. (He will be dead soon of venereal disease.)

MEASURE FOR MEASURE

In *Measure for Measure*, the duke of Vienna realizes that morality has become too lax under his rule. He decides to go on a sabbatical leaving his second-in-command, Angelo, to revive some old morality laws. He'll return disguised as a friar to see how the laws are being enforced and received.

Mistress Overdone is worried that all the bordellos will be closed, but Pompey tells her that her place of business will be protected. A young man, Claudio, is sentenced to death under the morality laws for having made his fiancée pregnant. He tells Lucio that he intended to marry Juliet but that her family held up her dowry. Claudio sends Lucio to get his sister, Isabella, an aspiring nun, to plead his case before Angelo.

Escalus, Angelo's second-in-command, suggests mercy for Claudio, but Angelo refuses. Pompey and Froth are brought before Angelo on charges of running a bordello. The officer's and Pompey's long-winded statements get the better of Angelo, who exits. Escalus pardons the two but warns them that the laws will be enforced next time.

Isabella pleads for Claudio, but Angelo says he won't pardon him unless she sleeps with *him* (Angelo). (What kind of a cad tries to subvert a nun?) She refuses and reports back to Claudio, thinking her brother will approve. (She needs to get out more.) Claudio wants to keep his head and asks Isabella to reconsider. The duke, dressed as the friar, overhears their conversation. He tells Isabella about Mariana, a woman who still loves Angelo although he has jilted her.

The friar proposes the "bed trick." Isabella will agree to Angelo's demand but make a demand of her own: that the couple will be in total darkness and will not speak. Then Mariana will substitute for Isabella. Sneaky Angelo, even though he thinks he's going to have his way with Isabella, arranges to have Claudio's head cut off. The friar intervenes by trying to substitute the head of another man due to be executed. (They don't kill him; he has a hangover and is unrepentant, so they would be sending him to Hell.) Luckily, another prisoner has died so they take his head.

Angelo satisfies his lust. The duke returns. Mariana tells the duke that Angelo has deflowered her. The duke exits, then returns disguised again as the friar, who accuses Angelo of immorality. Angelo calls for the friar's arrest, the disguise is knocked askew and the duke's identity is revealed. The duke sentences Angelo to die. Mariana and (can you believe it?) Isabella plead for Antonio's life. Claudio appears, still possessing his head. The duke pardons Angelo. Angelo marries Mar-

iana, Claudio marries Juliet, and the duke asks Isabella to marry him, which she does. Whew.

ALL'S WELL THAT ENDS WELL

If the happy ending of *Measure for Measure* stretches credulity, wait until the end of *All's Well That Ends Well*. As the play opens, the king of France is sick and expects to die. Bertram, son of the widowed countess of Rousillon, is going to the king's court. The countess wishes the father of her ward Helena were still alive. As a famed physician, surely he could have helped the king.

The virtuous Helena is in love with Bertram, but he ignores her; she's not highborn enough for his interest. Parolles is a braggart knight (though Bertram isn't wise enough to see that) who will travel with Bertram to France. After Bertram leaves, Helena gets the idea to take some of her father's prescriptions to the king.

The countess's steward has overheard Helena talking to herself about her love for Bertram. He reports this to the countess, who wheedles the confession out of Helena. The countess approves of Helena despite her low rank. Helena then tells the countess of her plan to go to France to see if she can heal the king, and the countess aids her.

In France, the king is loath to try anything

new, because his own physicians have given up. Helena finally bets her life that the treatment she has will work. She also asks the king for a husband of her choice if she is able to heal him. (Bet you can see where this is going.)

The king takes the medicine, gets better, and gives Helena a ring and her choice of mates. Helena chooses Bertram. He refuses to marry her, citing her low caste. The king throws the beginnings of a royal conniption fit, and Bertram caves. He marries her but doesn't consummate the marriage. He sends her to his mother's house with a letter, and runs off with Parolles to play soldier in Florence.

The letter tells Helena that he won't be her husband until she has his family ring and is pregnant with his child. Helena decides to become a pilgrim. She ends up (one guess) in Florence. She meets an Italian noblewoman whose daughter, Diana, is the object of Bertram's lust. So they play the bed trick on Bertram, with the twist that Diana first demands his family ring, and later in bed Helena gives him *her* ring.

During the war, Parolles is unmasked as a coward. Helena is reported dead in her pilgrimage; Bertram goes home and is offered a new wife, a nobleman's daughter. He gives her the ring he got in bed, and the king recognizes it as one he gave to Helena. Helena shows up with Diana, tells her story and says she's pregnant with Bertram's child. (What are the odds of that?) Bertram decides he loves her after all. The king's epilogue says that all things seem well. But none of us really believes it.

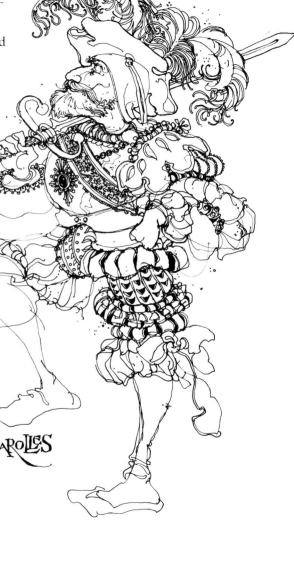

PAROLLES

Faraway Places with Strange-Acting People

W̲hat could the audience expect from a play set in Italy, Rome, Greece or Egypt? Every Elizabethan knew that the only place to find plain common sense, high-minded virtue and good Christian values was England. But if you needed a day off from your quest for rectitude, a play set in an exotic locale was likely to offer a nice banquet of silliness, unrepentant evil or naughty ideas. All of it was irresistible fare for rich and poor alike.❧

THE MERCHANT OF VENICE

This play makes many of us squeamish today. The Holocaust changed forever the way we view anti-Semitism, a main theme in *The Merchant of Venice*. Antonio, the merchant of Venice, reviles Shylock, the Jewish money-lender, and even spits on him when they meet in the street. Antonio is not today's idea of the good guy.

There's no getting around it; his attitude is part of the play and clearly reflects the prejudices of Elizabethan England. But before you get smug about your own tolerance, imagine this: a young Arab woman escapes a penurious father and elopes with a nice Lutheran boy from Minnesota. Be honest: don't you think the young woman has been saved from an awful life?

That's how Shakespeare's Christian audience would have seen Jessica's escape from her Jewish father, Shylock. When Antonio suggests, at the end of the play, that Shylock be allowed to keep half of his fortunes if he converts to Christianity, the audience believes Antonio shows extraordinary forgiveness and mercy in a kind of Renaissance tough love. By demanding Shy-

lock's conversion, Antonio is helping him save his immortal soul. As you might expect, this religious chauvinism gives modern audiences the vapors.

Notwithstanding these politically incorrect attitudes, Shakespeare created in Shylock a sympathetic character that we can understand. Shylock's desire for revenge makes sense, even though, to his detriment, he takes it a step too far.

The play begins with the wealthy merchant Antonio, who is fretting because all of his money is tied up in ships at sea. Sea travel being what it was (no Coast Guard rescue ships with helicopters, no ship-to-shore radio, no cell phones), this is a worrisome position to be in, as any MBA with a diversified portfolio could tell you. Several of Antonio's young friends are attending him, attempting to cheer him up and assuring him that all will be well.

When Antonio's friends prepare to depart, one stays behind. Bassanio is a young fellow with champagne tastes and a beer budget. He has supported his extravagance thus far by loans from friends like Antonio, but now he has met a wealthy young heiress and needs a lit-

tle more money to make an entrance as her suitor at her estate, Belmont.

The Belmont stakes are fairly high. Portia's late father left a test for any of Portia's suitors. There are three caskets, or boxes, at Belmont, one each of gold, silver and lead. Atop each is a tricky little verse describing its contents. In one of them is Portia's portrait and permission to marry her. In the other two are failure. The gold casket's sign says it contains what many men desire. The silver declares that whoever chooses silver will get all that he deserves. The lead casket has what sounds like a warning, that the chooser must give and hazard all he has. Anyone who tries and fails to guess which casket contains the portrait must promise not to reveal which casket he chose or what he found—and, more onerous still, he must promise never to marry.

Thus far, no one has dared take up the challenge. Bassanio is certain that he can choose the correct casket and asks Antonio for another loan to help. Antonio agrees to help even though this means that he must go to the moneylender, Shylock. (Presumably Bassanio cannot go directly to Shylock because his finances are such that Shylock would want something very important as security. Like Bassanio's head, maybe.)

Shylock reminds Antonio of the times Antonio has reviled him, spat upon him and criticized him for usury (charging interest on loans). But, Shylock assures him, that is all in the past. Shylock decides to loan him the money, without interest. The only thing he wants, and

Boys Who Dressed As Girls Who Dressed As Boys . . .

During Shakespeare's day, women weren't allowed to act on stage, so boys played the female roles. These boys, none of whose names we know, lived with the actors, playing saucy or demure parts as needed. (Imagine the National Endowment for the Arts requesting funding for *that*.) Maybe there are so few parts for women in the plays because boys who were willing to dress like girls were scarce, and they eventually grew beards.

But the boy actors added a layer of fun, especially in roles such as Viola in Twelfth Night *or* Rosalind in As You Like It. *In these plays, the witty remarks made by a girl pretending to be a boy were actually made by a boy pretending to be a girl pretending to be a boy.*

In the epilogue to As You Like It, *the actor who has played Rosalind tells the audience that if he were a woman, he would kiss the men who pleased him. Such gender-bending quips were sure to get a laugh and end the play on a high (tenor, not soprano) note.*❧

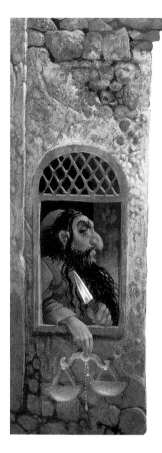

it's such a tiny little thing, and just for a joke really, is for Antonio to promise to give Shylock a pound of his flesh if the money is not repaid on time. This merry little exchange gives Bassanio the willies, and he counsels against the agreement. But Antonio is determined to help his friend and assents to Shylock's request.

At Belmont, the prince of Morocco and the prince of Aragon arrive as suitors. Each decides to take his chances in the box test, but Portia, who has met and liked the look of Bassanio from his previous visit, is unimpressed with either candidate and worried that one of them will choose correctly and thereby win her hand in marriage.

Bassanio, now properly outfitted, prepares to depart for Portia's estate, while Jessica, Shylock's daughter, prepares to flee her father's house, convert to Christianity and marry her beloved Lorenzo. To further that end, one of Lorenzo's friends invites Shylock to dinner, while signaling to Jessica that Lorenzo will come for her soon. When Jessica leaves, she takes a quantity of her father's money and jewels, which enrages him as much as her departure. It certainly doesn't help that she has married a Christian and the two of them have begun whooping it up on his (formerly) well-hoarded money.

In the days that follow, there comes a rumor that a Venetian ship has been lost and Antonio's friends worry that it is one of his. The prince of Morocco and prince of Aragon choose the gold and silver caskets respectively, are disappointed and leave Belmont in search of long-term platonic friendships. Bassanio arrives, chooses the plain lead casket and wins the lottery (to Portia's delight), and they marry.

But now, the date to repay Shylock has passed and Bassanio must hasten back to Venice with his newly acquired funds in order to rescue Antonio, whose ships are apparently lost. Antonio is bankrupt and in jail. Portia gives Bassanio a ring as a token and says she'll enter a religious retreat while her husband is away. This lasts until Bassanio is out the door. Then, with the help of a cousin, Portia hightails it to Venice, dressed as a man, where she masquerades as a lawyer sent by a legal scholar who has been consulted by the duke.

Here is where Shylock begins to make a very poor investment in the revenge business. Rather than accepting from Bassanio the money loaned to Antonio, Shylock implacably demands his pound of flesh—the pound around Antonio's heart, even though there's practically no aftermarket for that cut.

Portia, as the lawyer, makes a speech about mercy that would make a Texas jury weep, but Shylock still wants his pound of flesh. Portia gives Shylock several chances to show mercy and take the money, but he continues to demand the strict form of justice. Finally,

the lawyer concludes that Shylock may have his pound of flesh. Antonio prepares to die. But, says the lawyer, you mustn't spill even a drop of blood, because that's not part of your contract, and if you do it will be murder. (Shakespeare knew instinctively that women were masters of splitting hairs in arguments and would someday make excellent lawyers.) Shylock, who sees he has made a little misjudgment, says then that just the money will be fine and he was just leaving, no need to get up, et cetera, et cetera. But the legal scholar declares that Shylock, a non-Venetian who demanded the life of a Venetian, should himself be put to death and his wealth be forfeited unless the duke is merciful and decides to pardon him.

The duke of Venice allows Shylock to keep his life. Antonio suggests that the moneylender be allowed to keep half his fortune if he agrees to cede the other half to his daughter and convert to Christianity. Shylock agrees to this, and they allow him to depart.

Bassanio offers to pay the lawyer a fee but the lawyer declines, asking only for the ring that Portia gave to him. Bassanio (as any wise man would) tells the lawyer that he cannot give away this particular ring. Nonetheless, when the lawyer has departed, Bassanio feels guilty of ingratitude so he sends his servant, with the ring, after the lawyer.

When Bassanio arrives home, Portia meets him, having lately come back from her "religious retreat." She asks about the ring and after a bit of dissembling he tells her what he has done. Portia at first upbraids him. Then she produces the ring, revealing her part in the adventure. By letting Bassanio know that she has played the part of the lawyer, Portia gave him fair warning that she would be a formidable adversary in any argument. One cannot help but think that knowing this, Bassanio took great pains to be a most agreeable husband thereafter.

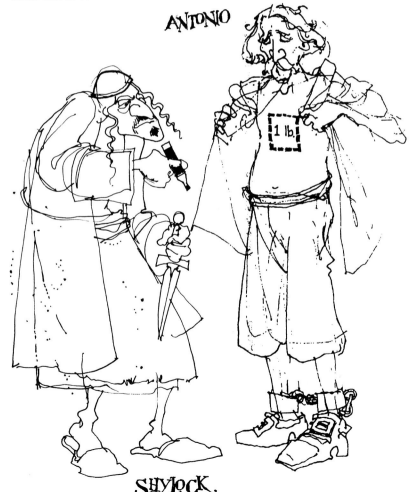

ANTONIO

SHYLOCK

HAMLET

You can hardly walk in the door of a production of *Hamlet* without Dr. Freud sauntering down the aisle alongside of you. It's possible that all that Oedipal stuff is cluttering up the catacombs at Elsinore castle (subconsciously, of course). Suppose you were the prince of Denmark. You come home from school for your dad's funeral, thinking, "Well, I'm going to have to give up the longest degree program in history and be king now."

But you get home, find your mother—whom you thought loved your father a great deal—has up and married your uncle within days of your father's funeral and your uncle, not you, has been securely installed as king. The court has gone from being a sober seat of governance to party central, and it all feels wrong. You don't have to have a crush on your mother to feel there might be something rotten in Denmark.

The play opens with castle watchmen seeing a ghost that looks like the late king. It seems to be a portent to them, perhaps of the coming war with Norway. The watchmen tell Prince Hamlet's friend, Horatio, about the visitation. He watches with them the following night and, seeing the apparition, decides they must tell the prince.

The new king and queen want Hamlet to stop wearing black and mourning his father. Hamlet wants to go back to Wittenberg, but Claudius the king wants him where he can keep an eye on him. The king tells Hamlet his mother will be happier if he stays home, so Hamlet agrees. Ophelia's brother, Laertes, wants to go back to his studies in Paris (and just what is he studying there?) and the king gives him leave to go. Before Laertes sets off, he tells Ophelia to watch out for Hamlet; guys are only after one thing (now we know what he's studying).

Polonius, Ophelia's father and a Danish lord, adds his two hundred cents, at the end of which he forbids Ophelia to have anything to do with Hamlet. This scene sets the stage for Ophelia's later insanity. She may be physically chaste with the knowledge of sin, but without the experience to make it understandable. Or she may have been innocently intimate with Hamlet out of love, which love was then made sinful by the ob-

scene remarks of those around her. In either case, Shakespeare knew that a good-looking crazy lady making up lewd songs and then drowning herself was great action, whatever the reason.

King Claudius writes a letter to the king of Norway telling him his nephew, Fortinbras, is threatening war on Denmark. He asks the Norwegian king to restrain his nephew. The king of Norway sends his nephew off to attack Poland. (Why not? Everyone else has.)

When the late king of Denmark's ghost appears, he beckons for the prince to follow. Horatio tells Hamlet not to go. He's been worried about his friend's state of mind and fears the ghost might lead the prince to a cliff and urge him to jump. Hamlet realizes

What's a Soliloquy?

—⟡—

Asoliloquy is a low-tech version of a voice-over. Before the invention of the microphone and audio recording, there was still a need to develop plot and character in just a few lines. A soliloquy, which is just one person talking to himself with the audience as a necessary eavesdropper, could give clues to past actions, the character's inner thoughts and motivations, and where the plot was heading.❧

he must go. If this is his father's shade, he has to know what it wants, what it can tell him.

The ghost describes the king's murder to Hamlet, and the prince becomes more convinced of his uncle's perfidy, but not completely so. Unlike Macbeth, who took the witches at their word, Hamlet has a healthy caution toward spirits. The ghost with the visage of his late parent might be a goblin sent to tempt him and damn his soul. But he believes enough to make him swear his companions to secrecy about the ghost and the insanity he intends to feign.

Ophelia's father, Polonius, sends a servant to Paris to spy on his son. King Claudius hires Rosencrantz and Guildenstern, young men who had studied with Hamlet, to spy on the prince. It takes Hamlet about half a second to figure this out. When a group of traveling players comes to the castle, Hamlet asks them for a particular play, "The Murder of Gonzago," amended with lines written by himself. The play parallels his own father's murder. If Claudius reacts like a guilty man, Hamlet will know the truth.

After Polonius informs the king of Hamlet's madness, brought on, the old man says, by lovesickness, the two men eavesdrop on the prince while he acts crazy

PEOPLE WHO DIE IN HAMLET

THE GHOST (HAMLET'S FATHER)

OUCH

POLONIUS

OPHELIA

BLURP

and is not very nice to poor Ophelia. That night, the visiting players put on the play, the king has a fit and runs out, and Hamlet has his answer. But when he finds the king at his prayers, the prince decides not to kill him, since a praying man would likely go to Heaven. One of the complaints of his father's ghost was that he was murdered with his sins unconfessed and unabsolved.

Hamlet goes on to Queen Gertrude's rooms and rants at her so that she cries out. Polonius, who has been hiding behind a curtain, yelps as well and Hamlet stabs him, saying he thought it was Claudius. Acting crazier by the minute, Hamlet takes the old man's body away and hides it. Claudius has had enough.

He'd love to have Hamlet hanged, but the prince is popular with the Danes so he counsels his nobles that Hamlet is dangerous and needs to be sent away from court. Rosencrantz and Guildenstern bring in Hamlet, who makes jokes about corpses and how you can find them by the smell, then tells them where he's hidden Polonius. The king orders Rosencrantz and Guildenstern to take Hamlet to England with a letter to the English king saying that Hamlet is to be killed.

So Laertes is gone, Polonius is dead and Hamlet has been sent away. Ophelia is alone in a culture where a woman without a man is like a fish without gills. Quite mad now, she wanders through the court singing strange ditties and giving everyone flowers. Although

her words are out of joint, there seems to be some sense to them, similar to Hamlet's feigned madness. She sings of a dead lover, then of a woman seduced, and wanders off.

Laertes returns from Paris and gathers a bunch of supporters who burst in on the court, demanding redress for his father's slaughter. King Claudius persuades Laertes that Hamlet is his enemy, not he, the king. Ophelia comes back, still insane, sings about an old man dying and then wanders out again. Claudius takes Laertes away to conspire out of Queen Gertrude's hearing. Ophelia drowns herself.

Somewhere on the way to England, Hamlet fixes the king's letter so that Rosencrantz and Guildenstern will be killed in England; then he escapes (with the clever use of pirates). He is now resolved to avenge his father's death and has come to terms with his own. He returns to Denmark just in time to see Ophelia's grave being dug.

The gravediggers have a little fun at the expense of the dead people around them. (This is where poor Yorick's skull is unearthed, though how in the world they know it's his skull is another matter. If it is his grave, why are they putting Ophelia in it? If it's a mass grave, how do they know the skull is Yorick's?) When the funeral procession arrives, Hamlet nearly gets into a duel with Laertes at Ophelia's graveside. Apparently, now that she is dead, he knows he loved her. (Timing,

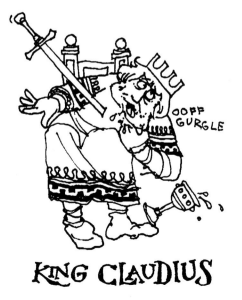

KING CLAUDIUS

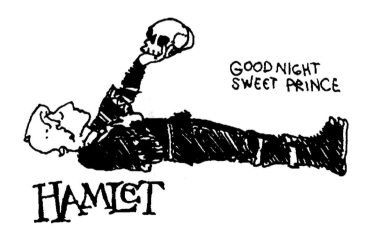

GOOD NIGHT
SWEET PRINCE

HAMLET

sweet prince, is everything.)

The king proposes a contest with blunted swords to settle the matter. Of course, Laertes is going to use a real sword, and one with poison on the tip to boot. The king tells Hamlet that he has placed a wager on him to win. Claudius drops a pearl into a goblet of wine, which also has a deadly poison. Claudius tells Hamlet the pearl is his reward. (Doesn't it remind you of a Danny Kaye movie? "The vessel with the pestle has the pellet with the poison.")

Laertes and Hamlet fight. The king tries to give Hamlet a drink but he says he's not thirsty yet. But the queen is thirsty and she wants a drink from Hamlet's cup. The king tries to stop her, but she drinks some of it anyway. Laertes pricks Hamlet with the poisoned sword. They fight some more and drop their swords. In the process of retrieving them, Hamlet gets Laertes' sword and wounds *him* with the poisoned blade. The queen keels over, saying she's been poisoned.

Laertes confesses the plot to Hamlet and asks forgiveness. Hamlet stabs the king with the poisoned sword and makes him drink the poison as well. Horatio wants to drink the poisoned wine, too, but Hamlet stops him: somebody has to live to tell the story. Hamlet dies, and Norway's Prince Fortinbras comes in, assumes control and orders a state funeral for the dead prince.

What's So Great About Shakespeare Anyway?

There's no doubt about it: Shakespeare had a way with words. There have been many wordsmiths through history, but none has so captured our collective imagination and reverence.

The greatest of Shakespeare's works captivate because while they may have been written around 1600 in the language and costumes of the day, the underlying themes are ageless.

Apparently, Shakespeare had the kind of mind that worked like one of those sticky mousetraps: wherever he went, whatever he saw or read, stuck. Sometimes the stuff that stuck had been written by other people. But if plagiarism hasn't been invented yet, it can't be illegal. To do him justice, Shakespeare may have nicked paragraphs from other writers here and there, but the real magic is in the distillation—like making great wine from your own and some of your neighbor's grapes. A cluster of Plutarch, a smidgen of Italian folktale, some crushing under the metaphorical feet of his imagination and voilà! Deathless prose.

Except that that's not quite all of it either. Shakespeare had plenty of occasions to emend his work. Each performance allowed him to tinker, to tweak, and to get a little closer to what he could hear and see in his mind. The people who came after him, inadvertently or on purpose, did their own tinkering.

What we have now is a body of work that encompasses eternal themes of human life: love, grief, ambition, revenge, despair, joy. Costume, vocabulary, custom and mode of living are small in comparison. The work lives on, because inwardly we have not changed at all in four hundred years. The man we know as Shakespeare worked within the trappings of his time but left us portraits painted from the unchanging essence of humanity.❦

KING LEAR

King Lear wants to let go the responsibilities of power but still live in the state of bowing and scraping kings get used to. A good headshrinker could have told him that was magical thinking and it never works, but if he was unwilling to listen to a perfectly good fool and an honest daughter, he probably wouldn't have listened to a shrink either.

So Lear must learn firsthand that breaking a kingdom in half (or thirds, which would have been the case if Cordelia were a flattering little liar like her sisters) is a special kind of sin that demands great sacrifice to set right.

Lear has decided to retire and split his kingdom between his sons-in-law. His daughter Goneril is married to the duke of Albany, and Regan is married to the duke of Cornwall. His youngest daughter, Cordelia, is not yet married but has two suitors: the king of France and the duke of Burgundy. Lear proposes to give the largest share of the kingdom to the daughter who loves him the most. Regan and Goneril vie for the title of Most Proficient Purveyor of Meretricious Mendacity. Lear is flattered and wants the same piffle from Cordelia.

He doesn't get it. Cordelia is honest and unskilled at exaggeration. She simply says she loves him as much as a daughter should love a father. Lear, who has truly let all the bowing and scraping go to his head, is incensed and tosses Cordelia out. The earl of Kent thinks the king may be a little hasty and says so. He gets himself banished. The earl of Burgundy suddenly finds Cordelia less attractive, but the French king offers to marry her and they go off to France. The other two sisters and their husbands receive half a kingdom each, but even so, the sisters get together to discuss controlling their father as he descends into his dotage.

Meanwhile, in another unbalanced noble family, Edmund, the illegitimate son of the earl of Gloucester, makes his father think that his legitimate son, Edgar, is plotting to take his life in order to hasten his inheritance. Edmund then dupes Edgar into thinking his father is dangerously angry with him and he should go everywhere armed.

After dividing his kingdom, Lear kept one hundred

knights as part of his retinue. Goneril, with whom he lives first, decides he's overstepping himself. She instructs her steward, Oswald, to disparage the old man and ignore his demands. The earl of Kent returns in disguise and joins Lear. When Oswald gets uppity, Kent knocks him around and chases him out. Goneril chides her father and demands that he send at least half his knights away. Lear's fool rails at him for giving up his power. Albany, Goneril's husband, objects to her actions. Goneril writes to her sister about how she's handling their father.

Edmund convinces Edgar that he needs to run away to avoid his father's murderous wrath. When their father appears, Edmund tells Edgar he should pretend to fight him, but he'll really help him get away. Once Edgar is out of earshot, Edmund persuades his father that Edgar was planning to kill him. Gloucester says he'll have Edgar caught and executed and that he'll declare Edmund legitimate. Edgar eludes the posse and decides to disguise himself as a lunatic. He scampers around shouting, "Poor Tom's acold."

Lear decides to go to Regan, since Goneril is proving to be a poor hostess. He catches up with her at the earl of Gloucester's house, where he finds Kent in the stocks. Regan's husband, Cornwall, had him put there for beating on Oswald again. Regan and Cornwall tell Gloucester that they don't want to see Lear. When Gloucester brings the message, Lear just barely holds onto his temper. Kent is freed when Regan and Corn-

wall come to welcome Goneril. The two sisters tell Lear to get rid of his knights. Lear is enraged and grieving. Unable to control the situation, he rushes into the storm. His fool and Gloucester go after him.

A message is sent to Cordelia, telling her of Lear's plight. Gloucester has been forbidden by Cornwall to give Lear shelter, but Gloucester knows a French invasion is at hand and seeks to help the old king. Edmund informs on his father, with an eye on early inheritance.

Out in the storm, Lear, Kent and the fool find a hovel. Lear sends the fool inside but stays in the storm himself. The fool runs back outside; he's found a madman in the shelter. Edgar, now known as Tom O'Bedlam, follows, ranting about being followed by devils. Lear begins to understand the lives of his poorest subjects as he watches Tom in his rags.

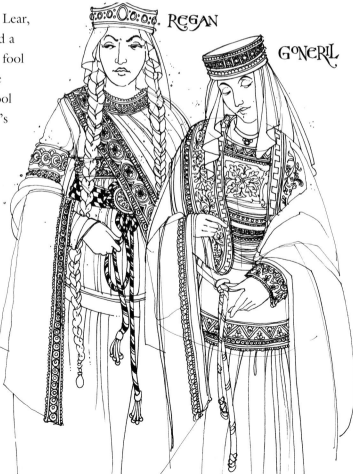

REGAN

GONERIL

Shakespeare du Monde, à la Mode and à la Carte

Ever wonder what Hamlet's "To be or not to be" speech would sound like in German or French or Japanese? You can find out! Hamlet has been translated into more than one hundred languages. In fact, Shakespeare's works are available in most languages, either in literal translations or as adaptations.

The universality of Shakespearean themes makes the plays attractive for translation. Envy, hate, passion and ambition do not belong to the western mind alone. But the interpretations may vary from culture to culture, with their different mores and rules.

The Japanese film director Akira Kurosawa adapted the themes of King Lear and Macbeth for his films Ran and Throne of Blood, respectively. Although the dialogue and characters may change in an adaptation, the important message of the play is sometimes more faithfully preserved when a director creates a unique cultural adaptation, than in a strict translation.

And of course Shakespeare begs to be parodied, no matter where you live. Some of the lines and situations are so well-known that they risk being their own satires. There has been voodoo Shakespeare, jazz Shakespeare, all-black, all-male, all-female Shakespeare. William would have been proud.❧

Gloucester finds Lear and takes him and his companions to a warm room. He later returns to them and tells them they must escape. Kent and the fool carry Lear, who has fallen asleep after his long tirade. But Edmund has shown his father's letters to the French to Cornwall. Gloucester is arrested and taken to Regan and Cornwall. When he threatens to see them punished, Cornwall puts out his eyes (and you thought your boss was tough.) A servant attacks Cornwall, who fights back and kills him but is mortally wounded himself. The servants help Gloucester escape.

Edgar, still in the madman guise, meets his father and grieves for the old man's injuries. When Gloucester wants to throw himself off a cliff, Edgar says he'll lead him to the cliffs of Dover. As they travel, they meet Lear, who is quite mad now and wearing plants and twigs in his hair.

Meanwhile, Goneril and Edmund have been making eyes at each other. Oswald tells them that the French are planning an invasion and that Albany, Goneril's husband, is glad of it but disturbed by news of Gloucester's blinding. Goneril charges Edmund with raising an army posthaste, and they exchange sweet nothings as he leaves. Albany enters and takes his wife to task. She thinks he's a coward, but Goneril is more worried about Regan moving in on Edmund, now that Cornwall has died.

Cordelia receives reports of Lear's madness and is

distressed. A doctor tells her that with rest and care he might be cured. A message comes with the news that the armies of Albany and Cornwall are at hand.

Goneril has succeeded in convincing Albany to oppose the French and sends Oswald with a message to her sister. Oswald also shows Regan a letter from Goneril to Edmund. Regan is not at all pleased with that and sends a little gift to Edmund to get his attention. She also suggests to Oswald that he go find and kill Gloucester.

Edgar has decided to let his father think he's jumping off a cliff in order to cure his despair. The old man falls forward on the ground and Edgar, now pretending to be someone walking by, tells him he'd seen him on the cliff's edge with demons. The old man decides to carry on with his life rather than sin in taking it.

A search party finds Lear and takes him to his daughter Cordelia. Oswald attacks Gloucester but is killed by Edgar. Edgar reads the letters to Edmund that Oswald has with him.

In one, Goneril tells Edmund he should kill Albany so he can marry her (what a nasty little strumpet!).

Lear and Cordelia meet but he thinks her a spirit. After a time, he begins to realize he isn't dead, but they put him to bed to rest.

Regan gives Edmund the third degree about Goneril. Goneril is so jealous of her sister's trying to horn in on Edmund that she'd rather lose the battle than lose Edmund to her sister. Edmund knows they need Albany's help during the battle, but he'd like Goneril to get rid of him after that. Albany would be merciful to Lear and Cordelia. Edmund doesn't want that.

Edgar comes in with another disguise on (where is this guy getting all these clothes?) and speaks to Albany privately. He shows him Goneril's letter to Edmund and suggests a fight between Edmund and a challenger after the battle.

Albany and the English army defeat Cordelia, who leads the French army. Cordelia and Lear are made captive. Edmund gives written instructions to an officer about what to do with them. Regan gets violently ill and leaves. Albany arrests Goneril and Edmund for treason and waits for the challenger. Edgar arrives and badly wounds Edmund, who confesses. Edgar reveals who he is. A report comes that Goneril confessed to poisoning her sister (who has died) and then killed herself. Edmund also tells Edgar that he sent someone to murder Lear and to make it look as if Cordelia has hung herself in her cell. Someone is sent to stop this, but too late for Cordelia. Lear carries her in. Albany offers him back his kingdom, but Lear, in a near-death vision, thinks he sees Cordelia breathe, and then he dies.

Getting Cozy with Will

1 Listen to or read a synopsis of the play. If you know what's going to happen, you can just enjoy the ride and the language won't get in the way.

2 See the play on film or on stage. Watch the actions, gestures and expressions of the actors. Some of the words may be strange, but you'll receive plenty of visual cues. Don't worry about what you don't get. You'll be surprised how much sense it makes.

3 Relax. The English teacher who made you learn Mark Antony's "lend me your ears" speech from Julius Caesar has been kidnapped by aliens. There's not going to be a quiz in the lobby.

4 Have fun. Shakespeare was writing entertainment, not literature. Put your imagination on autopilot and send your overachieving left brain out for a double espresso and hazelnut biscotti. You'll understand more if you don't try to comprehend every word.

5 Think a little naughty. If you think you've heard something a bit risqué, you probably have. The plays are full innuendo and double (or triple) meanings.

6 You're allowed to hate it. Loathing Shakespeare is not a sign of literary bad taste. George Bernard Shaw wasn't impressed with Shakespeare, and he did okay for himself.

7 Play favorites. If you love Romeo and Juliet and hate A Midsummer Night's Dream, or think Hamlet is divine and Titus Andronicus is disgusting . . . that's wonderful. Have a nice big opinion with your espresso and biscotti. Everyone from meter maids to microbiologists can put in their two cents' worth, and the plays still go on.

OTHELLO

There's little need to update *Othello* for modern viewers. Indeed, the story, with minor variations, plays itself out with sad regularity in the daily news the world over: Jealous Husband Kills Wife, Commits Suicide. However, in Shakespeare's hands, a woeful domestic drama takes on the tone of high tragedy as the forces of good and evil vie for control of a human soul.

The character of Iago is squarely on the "Evil" side. Like a plague or a sickness, he infects everyone with his virulent lies. Those he does not subvert, he dupes and uses. First, he tells Roderigo that Desdemona, the woman Roderigo has been courting, has eloped with Othello, a Moorish general working for Venice. Iago is an aide to Othello, but he hates him because he has promoted Michael Cassio over himself. Iago insists to Roderigo that Desdemona will come to regret having married a Moor.

Desdemona's father, Brabantio, is enraged over Desdemona's elopement. He and Roderigo accuse Othello in front of the duke of Venice and the senators during a council of war. (The Turks are planning to attack Cyprus.) What everyone discovers is that despite the differences in their ages and races, Othello and Desdemona are a happily matched couple. They are affectionate with each other, satisfied in each other's company and have very obviously married for love. The duke of Venice decides that Brabantio will have to live with his daughter's decision. He sends Othello off to command the army at Cyprus. Desdemona goes as well but on another ship.

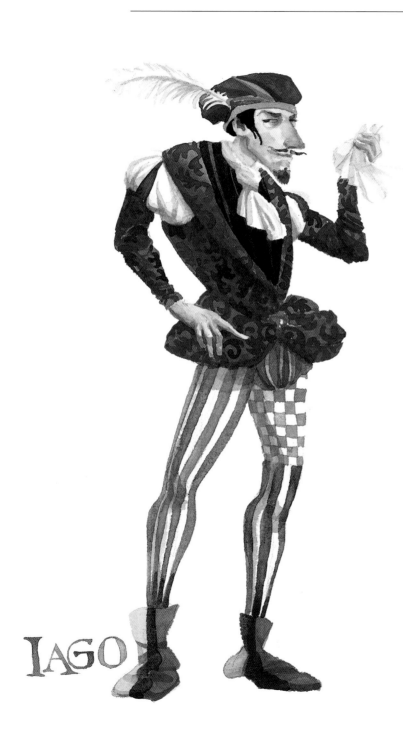

IAGO

A storm destroys the Turkish fleet, so we aren't going to have to worry much about the war. For a time, no one knows the whereabouts of Othello's ship, but he finally arrives safely. Iago tells the audience that he believes Othello has cuckolded him with his wife, Emilia, and that's why Iago wants to destroy him. He also calls Roderigo a fool and admits to using and getting money from him.

Othello declares a holiday to celebrate the destruction of the Turkish fleet. Iago tells Roderigo that the problem is that Desdemona is actually in love with Michael Cassio, and he convinces Roderigo to start a fight with Cassio while he's on duty. Then, at the celebration banquet, Iago gets Cassio drunk. When Cassio goes on duty and Roderigo baits him, Cassio chases him down the street and ends up dismissed from his post. Iago persuades Cassio to get Desdemona to plead his case with Othello.

Iago uses his own wife, Emilia, to take a message from Cassio to Desdemona so that they can meet. Cassio tells her his story, and Desdemona says that she will speak to her husband. Cassio retreats when Iago and Othello appear, which Iago takes pains to find suspicious for Othello's benefit. When Desdemona asks Othello to reinstate Cassio, he agrees, he says, because he loves her and cannot deny her. But once she has gone, Iago begins to pour poisonous words in Othello's ear. He asks leading questions and implies a sexual connection between Desdemona and Cassio, even

while pretending reluctance to talk about it.

The poison begins to work its way into Othello's psyche. His insecurities about being black in a white society and being married to a younger woman make fertile soil for the seeds of jealousy. When Iago suggests that Othello should wait a bit to put Cassio back in his post and to watch his wife's reaction, Othello agrees.

Othello hides his fears and disquiet when Desdemona and Emilia come to accompany him to a banquet. Desdemona accidentally drops a handkerchief, Othello's first gift to her, which Emilia retrieves. Before she can return it to Desdemona, Iago takes it. He intends to have it found on Michael Cassio. When Othello returns and demands proof of his wife's infidelity, Iago tells him that she has given a handkerchief to Cassio. Othello promises vengeance on his wife. Iago swears his loyalty and promises to kill Cassio.

Desdemona innocently tries to speak to Othello about Michael Cassio, but Othello is only enraged.

He demands to know where the handkerchief is. Desdemona swears it isn't lost. Othello tells her that he bought it from a sorceress who put a charm on it so that the woman who owns it would be cursed by her lover if she ever lost it. When she again takes the subject back to Cassio, Othello storms out. When Iago and Cassio enter, Desdemona says she is perplexed by Othello's change of temper, and the villainous Iago offers to go see what's wrong with him. Emilia says Oth-

Guess Who's Playing Othello?

The character of Othello is about four hundred years old, but it wasn't until the twentieth century that he was played by a man who didn't have to artificially darken his skin.

The Elizabethans (whose idea of political correctness began and ended with not aggravating royalty or anyone else they considered their betters) didn't believe that people from Africa were capable of acting. Subsequent generations weren't any more inclined to cast a black actor for the role than their predecessors had been. Finally, Paul Robeson played Othello opposite Peggy Ashcroft in a 1930 British production of Othello. American bigots blocked a planned tour of the show in the United States. Robeson played the role in 1942 when it toured several cities around the United States, and it had a long run on Broadway. This casting made history, not only in the theater, but also in the civil rights movement. Desdemona, sadly, ends up dead in all of the productions.

ello might be jealous, even if he has no cause. Desdemona decides she should speak with him again.

Cassio is left alone but a prostitute he knows (Bianca) appears, scolding him for avoiding her. He gets her off his back by asking her to copy a handkerchief that he has found. Iago tells Othello that Cassio admits to having slept with Desdemona. Feverish with rage and grief, Othello at first sputters incoherently, then faints. Cassio appears and Iago gets rid of him by telling him he has important information that he'll convey to him privately as soon as Othello has recovered enough that Iago can leave him.

When Othello revives, Iago suggests that he listen to his conversation with Cassio and get further proof of the affair. Then Iago speaks to Cassio about the woman he has been seeing. Cassio replies disdainfully about the woman because she thinks he's going to marry her. Nearby, Othello listens and thinks Cassio is talking about his wife. Bianca enters and berates Cassio about the handkerchief because she suspects another woman gave it to him. Othello is aghast, thinking Cassio gave Desdemona's handkerchief (his very first love token to her) to a whore.

When Cassio and Bianca depart, Othello again swears

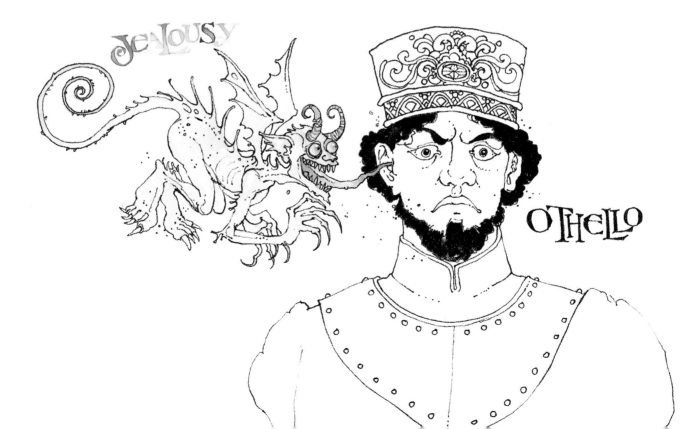

to Iago that he's going to murder Desdemona. Iago replies that he himself will kill Cassio that very night. Desdemona enters with a messenger who tells Othello he is being recalled to Venice and that Michael Cassio will be in command on Cyprus. Othello, seeing his wife pleased by the news, hits her. He sends her away and then exits himself. The messenger is shocked, but Iago assures the man that the general's behavior is often much worse.

Emilia tells Othello that Desdemona is faithful, but he doesn't believe her. She sends Desdemona to him. Desdemona enters and denies any wrongdoing, but he doesn't believe her. When Emilia comes back, Othello leaves, raging. Iago and Emilia tell Desdemona everything's going to be all right. After Emilia and Desdemona leave, Roderigo enters and chides Iago for taking his money but doing nothing for him. Iago says they must kill Cassio so that Othello and Desdemona will stay on Cyprus where Roderigo can get to her.

Othello tells Desdemona to prepare for bed and to dismiss Emilia, and then goes out. Desdemona says she loves her husband, but sings a song about a woman who was abandoned and then died. Although Desdemona finds the idea repugnant, Emilia says that men deserve adultery, because that's the only way a woman has to get even with a man.

Iago's plot to have Roderigo kill Cassio (and perhaps get Roderigo killed) goes awry. Cassio wounds Roderigo. Iago slips behind Cassio and stabs him in the back, then runs away. Othello is pleased that Cassio is wounded and appears to be dying. Witnesses appear and Iago returns. Pretending rage at the attack on Cassio, he kills Roderigo. When Bianca appears, Iago says she must have been involved and has her arrested.

Othello returns to where Desdemona is sleeping. He decides to smother her so that he won't destroy her beauty. (Frankly, death in any form doesn't do much for your looks.) She wakes and he tells her to say her prayers, because he's going to kill her for adultery. She protests her innocence, saying that if he'll only ask Cassio, he will support her story. But Othello tells her that Michael Cassio is dead. Desdemona pleads for mercy. He smothers her with a pillow. She's not quite dead, so when Emilia comes in, she can tell her she's innocent, and then she dies.

Othello tells Emilia that Desdemona had been unfaithful, but Emilia says it isn't true. When Othello says that Iago proved it, Emilia calls for help and Montano, Gratiano and Iago appear. Emilia tells the truth, that Desdemona unknowingly dropped the handkerchief, and that Iago had taken it for his own purposes. Iago stabs her and runs away. Othello realizes what has become of his love, his marriage and his life. He grieves for his wife and what he has done. Iago is brought back, and Othello wounds him. Othello is then disarmed and says he has been a fool, but hasn't been dishonorable. He draws a hidden weapon and takes his own life.

TIMON OF ATHENS

Timon is an Athenian noble attempting to live an idealized life of generosity. The play begins as he proposes to honor the debts of Ventidius so that the man will be released from prison. Timon spends lavishly and gives a feast for his friends, including Ventidius. Having recently inherited a fortune, Ventidius can now repay his debt to Timon, but Timon refuses.

The misanthropic Apemantus spends time insulting everybody for their vanity and greed. Timon's steward worries about his master's own finances. Timon's lifestyle comes to the attention of a senator to whom Timon owes money. The senator decides to collect his debt before there's nothing left to collect. This begins a landslide of demands, and soon Timon is bankrupt. He asks various friends for help and gets absurd excuses but no money. More debt collectors plague Timon, who asks if they'd like to cut up his body, since that's all there is left to divide. He then throws a party for his alleged friends.

At the senate, General Alcibiades is asking clemency for a friend, a former soldier who's gotten into a fight and killed someone. The senators are unmoved, but Alcibiades keeps talking and soon they banish him. He says he, and more importantly his army, will get even.

Back at the party, the dishes are uncovered and they contain only tepid water. Timon curses all his friends and chases them out. Then he curses the city and goes off into the wild. The steward grieves and goes in search of him.

Timon digs roots for food and finds gold, which he curses and distributes, hoping to cause evil. General Alcibiades meets Timon and offers friendship. Timon disdains it and sends the general away, though he loves the idea of Athens being attacked.

Apemantus brings Timon food, which the Athenian refuses. Apemantus notes that Timon has gone from one extreme to another, but he much prefers the bitter Timon to the idealistic one. Thieves come and steal the gold, which Timon praises. His loyal steward arrives, and Timon concedes that he's an honest man, but Timon won't have him as a servant. He drives him off.

True to his new character, Timon gives gold to anyone who seeks him out and then curses them and drives them away. Two senators seek him out, begging for his help in their fight against Alcibiades. They even promise to restore his former wealth. Timon suggests that the Athenians hang themselves. He says the epitaph on his gravestone can help them.

Alcibiades sends a message to Timon, but the messenger finds nothing but a grave and a note saying Timon is dead. The messenger cannot read the gravestone but copies the epitaph. A group of senators beg the victorious Alcibiades for mercy. He pardons everyone except the ones who'd done him ill. The messenger returns with the copy of Timon's epitaph, which restates his hatred of mankind. Alcibiades mourns Timon but decides to forgive the Athenians.

Not much to get your teeth into here, but the insults and curses are terrific.

*Would thou wert clean enough to spit upon,** & Other Useful Insults

I will begin at thy heel, and tell what thou art by inches, thou thing of no bowels, thou!
—TROILUS AND CRESSIDA, ACT II, SCENE 1

If her breath were as terrible as her terminations, there would be no living near her; she would infect to the North Star.
—MUCH ADO ABOUT NOTHING, ACT II, SCENE 1

Away, you scullion! you rampallian! you fustilarian!
—II HENRY IV, ACT II, SCENE 1

Thou hast no more brain than I have in mine elbows.
—TROILUS AND CRESSIDA, ACT II, SCENE 1

Out, you mad-headed ape.
—I HENRY IV, ACT II, SCENE 3

A knot you are of damned blood-suckers.
—RICHARD III, ACT III, SCENE 3

The devil damn thee black, thou cream-faced loon!
—MACBETH, ACT V, SCENE 3

Hence, heap of wrath, foul undigested lump.
As crooked in thy manners as thy shape.
—II HENRY VI, ACT V, SCENE 1

*TIMON OF ATHENS, ACT IV, SCENE 3

TITUS ANDRONICUS

If you liked *Nightmare on Elm Street*, you'll love *Titus Andronicus*. The tale is gruesome enough for teenagers: blood, evil plots, sex, mutilation, decadence, infidelity, insanity, revenge and a medium-rare look at Roman cuisine. After its initial popularity (except for a brief revival in the eighteenth century), *Titus Andronicus* was the least performed of Shakespeare plays up until Olivier's famous interpretation of

Titus in 1955. This play doesn't feel like Shakespearean tragedy because there's none of the moral framework we see in later Shakespearean plays like *King Lear* or *Macbeth*.

The play begins with Saturninus and Bassianus, two sons of the late emperor, vying to succeed their father. Titus Andronicus returns from the wars with the captives Queen Tamora, her slave/paramour Aaron and her three sons. Titus chooses one of Tamora's sons to be killed as the customary postwar sacrifice. The queen pleads for his life. Tamora's pleas do not move Titus, and Alarbus is taken away and killed. Needless to say, Tamora is a little put out.

Titus then throws his support to Saturninus, the elder son. Saturninus wants to marry Titus's daughter, Lavinia, which Titus agrees to although she's betrothed to Bassianus. When Titus's own sons help Bassianus run away with their sister, Titus kills one of them. Saturninus then asks Tamora to marry him.

Saturninus is threatened by Titus and uses Lavinia's flight to turn against him. Tamora pretends to defend Titus. Saturninus gives in to Tamora's prompting, and the couple plans a double wedding (with Bassianus and Lavinia), followed by a hunt.

Aaron plots against Titus as well, partly as revenge

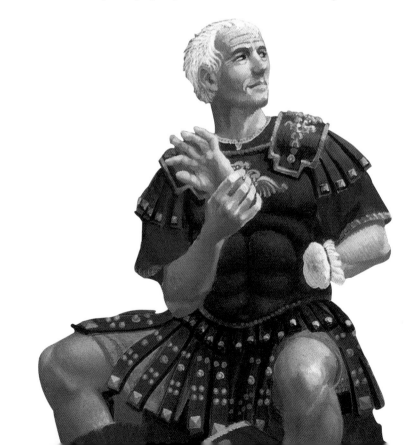

but mostly because he's just a bad egg. Tamora's other sons, Demetrius and Chiron, are lusting after Lavinia, so Aaron suggests that they rape her during the hunt. Chiron and Demetrius waylay Bassianus and Lavinia. They kill Bassianus and drag Lavinia away. Aaron throws Bassianus's body in a pit and drops in a letter implicating Titus's sons, Martius and Quintus, who are led off to await execution. Titus's brother Marcus finds Lavinia in the woods, ravished and with her tongue cut out and her hands cut off.

Aaron convinces Titus that if he cuts off one of *his* hands and sends it to the emperor, his sons' lives will be spared. Later, the hand is returned, accompanied by the sons' heads. Titus vows revenge and sends his one remaining son, Lucius, to raise an army. Lavinia figures out how to tell her father who raped her.

Titus pretends to go crazy. The emperor (Saturninus) is suspicious and would like to kill him. Before this can happen, Lucius marches on Rome with a Goth army. Saturninus sends an envoy to Lucius. They agree to meet at Titus's house. Tamora and her sons also go to Titus's house, where she pretends to be the allegorical figure "Revenge" offering him help. Titus feigns belief and sends her home, while keeping her sons there. After she leaves, Titus cuts their throats. He makes a pie with their heads, which he serves to Tamora and the emperor when they arrive.

Next Titus murders his ravaged daughter, with some excuse about the honor of his family. Titus then tells Tamora what, or rather whom, she has been dining on. She retches and he stabs her to death. The emperor kills Titus and Lucius kills Saturninus and becomes emperor himself. No great moral vision appears, but there is lots of pleasurably vicarious viciousness.

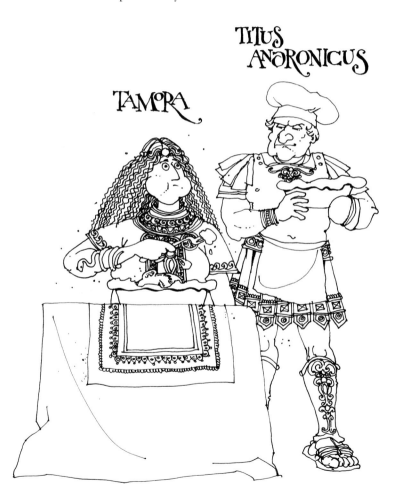

TITUS ANDRONICUS

TAMORA

ROMEO AND JULIET

Thank goodness Shakespeare tells us up front that these doomed teenagers are going to take their own lives. It's difficult enough to learn that the young generation must be sacrificed in order to heal a feud between noble families, without first setting us up with false hopes.

The play begins with a near brawl between two feuding families, the Montagues and the Capulets, brought on by the posturing of their servants. But the townspeople of Verona are heartily tired of the feud and the blood spilled because of it. Prince Escalus is incensed at the repeated disturbances and tells both families that if any one of them creates a further problem, the combatant's life will be forfeit.

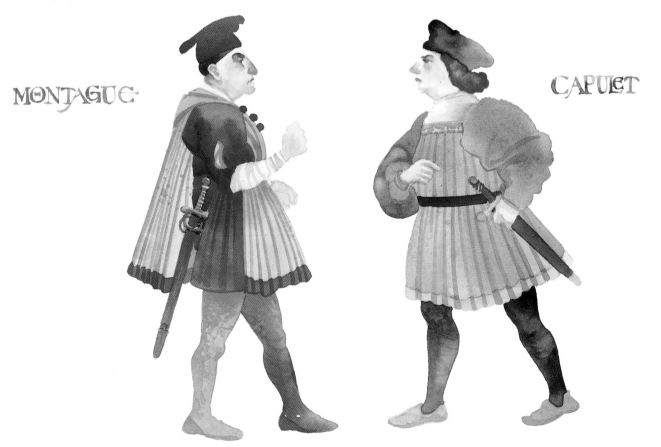

MONTAGUE

CAPULET

The two lovers first appear in the play separately. Romeo is seeking idealized love and he is full of high-blown clichés about the melancholy he believes he feels. And when Juliet is told that her father is considering a marriage proposal for her from Paris, a cousin of Prince Escalus, she is a quietly obedient child ready to do as she is bidden. Separately, Romeo and Juliet are reminiscent of the not particularly original lovers Claudio and Hero, from *Much Ado about Nothing*, who, despite a few setbacks, are destined to live happily ever after.

But Romeo and Juliet aren't destined for happiness. Once they meet and discover love, they're transformed into exquisitely tragic characters. Their passion flames so brightly that a single wedded night will have to last for eternity. The language of the play marries concepts of love and death so intimately that all the lovers' speeches are full of dark portents even before they know each other. Juliet says to her nurse, "Go ask his name. If he be married,/My grave is like to be my wedding bed." The gloom of approaching tragedy is already evident in her speech.

They meet when Romeo, in disguise, sneaks into a Capulet party with his friends Mercutio and Benvolio in order to glimpse Rosaline, a lady who has declared herself dedicated to chastity and whom Romeo fancies that he loves. Mercutio teases Romeo mercilessly. He has a more cynical view of women and love, which provides a spicy (and often bawdy) counterpoint to all Romeo's sighing.

Romeo and Juliet then meet and fall in love. At the banquet, Juliet's cousin Tybalt recognizes Romeo, but her father will not allow a fight to mar the festivities (and he's probably not keen on testing the prince's edict). The young lovers soon discover that they are from rival families, but though appalled by the news, they cannot now change the course of events.

After the party, Juliet goes onto her balcony where she speaks of her love for Romeo, who replies to her from the garden. She says:

> *How camest thou hither, tell me, and wherefore?*
> *The orchard walls are high and hard to climb,*
> *And the place death, considering who thou art,*
> *If any of my kinsmen find thee here.*
> Romeo replies,
> *With love's light wings did I o'erperch these walls,*
> *For stony limits cannot hold love out,*
> *And what love can do, that*
> * dares love attempt;*
> *Therefore thy kinsmen are no*
> * stop to me.*

Reluctantly the two part when Juliet's nurse calls her in. But before she goes in, they make a plan to slip away the next day to see Friar Laurence and get married. Romeo never goes home to bed but meets Friar Laurence in the very early morning to ask his aid

in marrying Juliet. The friar, who has often counseled Romeo to stop mooning over Rosaline, chides him for fickleness but at last agrees to help him, if only to end the feud between the warring families.

Waiting at home for Romeo is a letter with a challenge from Tybalt. Romeo's friends Mercutio and Benvolio discuss Tybalt's challenge and his skill as a duelist. In a not-so-complimentary way, they wonder whether Romeo is up to a fight with Juliet's cousin. Romeo meets Benvolio and Mercutio on his way home, with Mercutio still teasing and Benvolio still trying to figure out what Romeo's up to. Juliet's nurse meets them and is mocked by Mercutio. Romeo sends his friends away and sends the nurse home to bring Juliet to where they must meet Friar Laurence.

After the marriage, Tybalt meets Benvolio and Mercutio, who is so witty he's about to get himself killed. Mercutio wants to start a fight. When Romeo arrives, Tybalt is insulting, but Romeo declines to take the bait (they are now cousins by marriage even if Tybalt is unaware of it). Mercutio can't stand Romeo's restraint and draws his sword. He and Tybalt fight, but Romeo steps between them. In a sneaky little maneuver, Tybalt steps close to Romeo's raised arm and stabs Mercutio. Tybalt and his followers depart. Mercutio is mortally wounded, which gives him just enough time to tell everyone that he's dying— "Ask for me tomorrow and you will find me a grave man." Tybalt returns, and Romeo fights with and kills

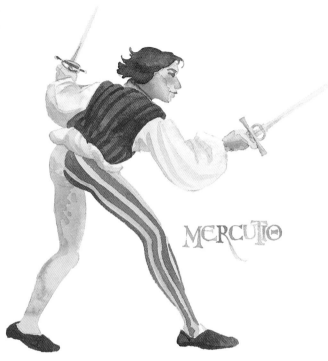

MERCUTIO

him. He then flees at Benvolio's prompting.

Romeo is banished by the prince rather than being sentenced to death because Tybalt was at fault as well. Juliet is horrified, which her father sees as too much grieving for her cousin. He immediately decides she should get married, one of those interesting leaps of male logic that defy interpretation.

When Romeo hears he's been banished, he speaks of suicide. Friar Laurence suggests that he spend a

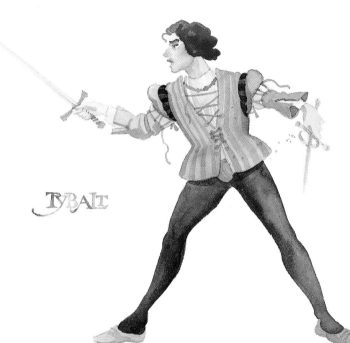

TYBALT

night with Juliet and then go to Mantua instead while things get sorted out. The young pair spends their single night of wedded bliss together and Romeo leaves for Mantua. Juliet's parents propose that she marry Paris and she, of course, refuses. Her father rages, and Juliet's nurse suggests that she just forget her marriage to Romeo and marry Paris.

Plans for her marriage to Paris continue, will-she, nill-she, and Juliet goes to see Friar Laurence, also talk-

ing of suicide. Knowing that she is already married, Friar Laurence is at some pains to help her avoid the marriage to Paris. He gives Juliet a potion that will make her seem dead. Friar Laurence then sends a messenger to Mantua where Romeo is staying.

Alone that night, Juliet is afraid the potion will kill her, and even if it doesn't she knows she'll wake up in a crypt alone with Tybalt's not-very-nice corpse for company. Juliet shows just what she is made of when she drinks the potion and surrenders to fate.

In Mantua, Romeo hears of Juliet's death and goes to an apothecary, where he buys a poison. He then heads back to Verona so he can be reunited with Juliet in death. Friar Laurence learns that the messenger he sent to tell Romeo of the ruse with the potion has been unable to reach the young man. The friar heads toward the Capulet vault, hoping to move Juliet's body until she awakens and Romeo can be found.

Paris (who seems to have sincerely loved Juliet) and his page go to the Capulet vault. The page warns Paris of someone's approach, and they see Romeo and Balthazar come to the tomb. Romeo sends Balthazar away with a letter to his family, but Balthazar hides nearby to watch. Romeo then prepares to enter the vault, but Paris steps forward and challenges him. They fight and Romeo mortally wounds Paris, who begs Romeo to lay him in the vault with Juliet. Romeo is distraught when discovers that it's Paris he has killed, a kinsman of Mercutio. He enters the tomb bearing

He Said, She Said

ROMEO: . . . *Ah, dear Juliet,*
Why art thou yet so fair? Shall I believe
That unsubstantial Death is amorous,
And that the lean abhorred monster keeps
Thee here in the dark to be his paramour?
For fear of that, I will stay with thee,
And never from this palace of dim night
Depart again. Here, here will I remain
With worms that are thy chambermaids; O, here
Will I set up my everlasting rest,
And shake the yoke of inauspicious stars
From this world-wearied flesh. Eyes, look your last!
Arms, take your last embrace! and lips, O you
The doors of breath, seal with a righteous kiss
A dateless bargain to engrossing death!
Come, bitter conduct, come, unsavory guide!
Thou desperate pilot, now at once run on
The dashing rocks thy sea-sick weary bark!
Here's to my love! [Drinks.] *O true apothecary!*
Thy drugs are quick. Thus with a kiss I die.
 [Dies.]
. . .

JULIET: *Yea, noise? Then I'll be brief. O happy*
dagger, [Taking Romeo's dagger]
This is thy sheath [stabs herself]; *there rust, and let me die.*
[Falls on Romeo's body and dies.]

—ROMEO AND JULIET, ACT V, SCENE 3

Well, they say that women go on and on. But please notice that
Ophelia and Lady Macbeth die quietly offstage, and even Queen
Gertrude got the job done in just three lines.

Paris's body and finds Juliet, apparently dead. He has no further hope and so drinks his poison.

Arriving just a few moments too late, Friar Laurence enters just as Juliet wakes. He tells her what has happened and attempts to get her to run away; he can hear the watchmen approach. Unable to persuade her, he flees himself. Juliet sees Romeo lying nearby and, finding none of his poison left, takes his dagger and stabs herself.

The watchmen apprehend the friar and Balthazar. The prince of Verona, the Capulets and Romeo's father come to the scene, where the friar tells them what has transpired. Romeo's letter to his father and Balthazar's testimony corroborate the friar's tale.

The prince cries out,

. . . *Where be these enemies? Capulet! Montague!*
See what a scourge is laid upon your hate,
That Heaven finds means to kill your joys with love.
And I for winking at your discords too
Have lost a brace of kinsmen. All are punish'd.

The Capulets and Montagues, grieving and chastened, have found a bitter peace, but not just an uneasy truce. In their awful loss, the families finally have a change of heart, and Romeo and Juliet are laid to rest together.

MACBETH

The play opens with a meeting of three witches on a desolate heath in a crashing Scottish storm. They are discussing Macbeth, thane (nobleman) of Glamis, who has just fought successfully on behalf of his cousin, King Duncan, against a rebellion by the thane of Cawdor. (When the king hears of the fierce fighting of Macbeth and his friend Banquo, he dispatches messengers to tell Macbeth that he will now be thane of Cawdor.) The witches continue their confabulation, each describing some capricious or spiteful evil she has performed. Their malice is so wanton that they immediately appear suspect. Macbeth and Banquo arrive. The witches hail Macbeth as thane of Cawdor, then go on to call him "king hereafter". Banquo doesn't want to be left out and asks what they see in the future for him. Banquo, they say, will never be king but will be the sire of kings. The witches disappear, and the messengers of Duncan arrive and, true to the witches' prediction, address Macbeth as thane of Cawdor.

So, thinks Macbeth (who admits to himself that he has kingly ambitions), one of the witches' predictions has come true; therefore, the other must be inevitable. This type of flawed but sweet-to-the-ego reasoning is almost as dangerous as believing the press releases put out by your own public relations department. Are the witches' statements warning or prophecy? Do we control our destinies, or are they preordained and we can only play through our assigned part? Macbeth chooses to believe the witches speak prophecy.

When Macbeth and Duncan next meet, Duncan expresses his appreciation for Macbeth's efforts on his behalf. In fact, the king would like to visit Macbeth's castle. At the same time, Duncan publicly proclaims his own son, Malcolm, the official heir to the throne. Macbeth rides to Inverness ahead of the royal party and muses on the fly in the ointment that Duncan has created by making Malcolm next in the line of succession. Macbeth believes that he himself is to become king, so what's going to happen to Malcolm?

When Lady Macbeth hears through a letter what the witches said, she shows off a prodigious ambition and sounds like a blend of Genghis Khan and Joan Crawford with two scoops of tarantula thrown in for creepiness. When her husband arrives and tells her that

Duncan is en route, she jumps right past the niceties and goes for a plan of regicide. Macbeth is hesitant. He considers the state of his immortal soul vis-à-vis the ramifications of regicide in this world. Lady Macbeth, after a good many insults to Macbeth's manhood, tells him that *she* will take care of the murder.

Banquo and Macbeth discuss the witches. Banquo is worried about the temptations of ambition. In an effort to hide his true thoughts from Banquo, Macbeth dismisses the effect of the witches. He has less success hiding his thoughts from himself and hallucinates a bloody dagger hanging in the air.

Duncan comes to Inverness; Lady Macbeth drugs the guards and sends Macbeth to kill Duncan. (She would have killed the king herself, but as he lay sleeping, he reminded her of her father.) Macbeth does the deed but comes back to her still carrying the daggers that were to be left with the guards. He fears he has damned himself. Lady Macbeth takes the daggers back to the sleeping guards and gets the spot of blood on her hand that plagues her so much later.

Lennox and Macduff, two other Scottish nobles, arrive in the morning. Duncan is discovered murdered. Macbeth, pretending a mad rage, kills the guards before anyone can ask them any questions. Duncan's sons, Malcolm and Donalbain, flee, fearful that they may be next in line for slaughter. Of course, this makes everyone think they had a hand in their father's murder, so Macbeth is crowned king of Scotland.

Banquo is suspicious of Macbeth, and Macbeth is worried about what Banquo may do. So, he sends a couple murderers to kill Banquo *and* his son Fleance (which will take care of that pesky prophecy about Banquo being the father of kings). Banquo is killed, but Fleance escapes.

Banquo's ghost comes to visit Macbeth during the evening's banquet. Only Macbeth can see the ghost, and he suffers a case of the willies. Lady Macbeth tells the assembled nobles that Macbeth is suffering from an old illness. The ghost leaves and Macbeth gathers his wits. But the specter returns once more, and Macbeth

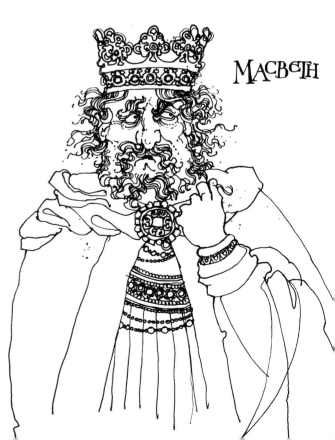

MACBETH

finds it difficult to function as the expansive host while staring at the shade of a friend he's had murdered. The great Macbeth feast turns out not to be the social event of the season.

Macbeth is caught in a net begun by his first crime. With each heinous act, he remains fully aware of the evil he is committing in service to his ambition. Not quite a sociopath, Macbeth made the first wrong decision that put ambition before morality, yet he cannot abandon the understanding of his immorality. He becomes caught up in the turn of events as one evil act follows another. He is aware and anguished, but, like someone caught in the maelstrom, he cannot draw back from what he himself has set in motion. Macbeth decides to check in with the witches.

Lady Macbeth, mirroring Macbeth's internal despair, is becoming more wretched and desperate over her part in her husband's grisly acts. With each of his acts of vio-

King Macbeth, ca. 1050

There was indeed a Scottish king named Macbeth, but he didn't bear much resemblance to the character in Shakespeare's play.

Oh, he was ambitious enough, but he merely started a civil war, and King Duncan fell in battle. Apparently the succession of Scottish kings was a bit like a royal game of king of the hill. If a man with any claim to royal blood could assemble a strong enough force to knock his opponent off the throne, he could become king. If the reigning king happened to fall in such a way that his head was cut off, well, that was just the cost of doing kingship in the north.

The real Macbeth wasn't without claim to the throne. He was a grandson of Malcolm II who had murdered his cousin, Kenneth III (who was grandfather to Lady Macbeth whose name, poor thing, was Gruoch). But Malcolm named Duncan, also one of his grandsons, as his successor, though this cut very little ice in eleventh-century Scotland and seems not to have deterred Macbeth at all.

After defeating his cousin Duncan, Macbeth ruled for about fifteen years, until Duncan's son Malcolm returned from exile with an army and defeated Macbeth in battle.

The regicide portrayed in Macbeth was probably adapted from an account of the murder of King Duff, King Malcolm II's uncle. It sounds bloody enough but probably wasn't too far from business as usual in the tenth century. By Shakespeare's day, however, the idea of bloody civil war was anathema to the growing middle class engendered by the Renaissance.

Shakespeare was also well acquainted with medieval morality plays, which were dramas created to teach spiritual lessons. He created timeless and universal stories and characters by mixing a taste of history with the engine of medieval morality plays.

Witches, Ghosts and Foul Fiends

The sense of evil incarnate in Shakespeare's day is hard to comprehend in our own. The physical and spiritual worlds were more closely conjoined. The soul's battle between good and evil was more public then, with a tinge of public participation.

We should be immediately suspicious, therefore, of the three witches who appear at the beginning of Macbeth. They have knowledge, but it is wicked learning, spit up from the pits of hell. Their speech is full of ambiguity and double meaning: "When shall we three meet again? When the hurly-burly's done, when the battle's lost and won." Their interests lie outside the service of either winners or losers. The witches serve the evil force that vies with good to rule the world. Men are the pawns of this struggle. Macbeth, as a Christian, should have known this, but his ambition made him blind. By the time Banquo's ghost crashes his party, King Macbeth is largely past salvation. He has killed his king and had his best friend murdered.

The ghost of Hamlet's father doesn't appear to Hamlet to frighten him but rather to inform and demand revenge. This ghost, however ominous, is also to be pitied. When he lived, he was a beloved king. Murdered in his sleep, with his sins unconfessed, he cannot enter heaven.

Young Hamlet, like any good Christian, is only partially convinced by the ghost of his father. The shade might be a counterfeit, something sent from hell to bewitch and bewilder the prince.

In Julius Caesar, Caesar's ghost pays a visit to Brutus to let him know it's time to commit suicide. But Richard the Third takes the grand prize with no less than eleven ghosts—of people the king murdered—who come to tell him his royal goose is cooked.

lence, she descends further into madness.

Somewhere in a dank and yucky cave stocked with bat wings, eyes of newts and other questionable condiments, Hecate, a goddess of the underworld and a very nasty bit of business as well, is in a snit because the witches didn't include her in their fun with Macbeth. She urges them to beguile the king (and have some perverse fun at his expense) with their predictions. When Macbeth arrives for a visit, the witches raise three apparitions. A disembodied head tells him to beware of Macduff. A bloody child tells him "none of woman born shall harm Macbeth." The third, a crowned child, tells Macbeth that he's safe unless Birnam Wood marches to Dunsinane (his castle).

People have grown suspicious about Banquo's death. The murdered king's son, Malcolm, now has the support of the English king against Macbeth. Macduff has gone to England to support Malcolm. The country is coming apart at the seams. When Macbeth learns of Macduff's defection, he sends assassins to murder Lady Macduff, all the Macduff children and all of Macduff's followers. This act is so repugnant, so far beyond the bounds of humanity, that it now becomes necessary to see Macbeth pay with his life.

Malcolm tests Macduff's loyalty to him and to Scotland by falsely confessing to immorality and perversity. When Macduff is aghast and distraught for his country, Malcolm knows he is a true friend and provides the Shakespearean version of "sorry, just kidding."

News comes of the slaughter of Macduff's family, and Macduff is brought low by grief. Malcolm urges Macduff to take his revenge on the field of battle. They raise an army and set out to bring down Macbeth.

King Macbeth is unconcerned about the army, since Birnam Wood is not about to stand up and move. Lady Macbeth has begun having hallucinations and doing the "Out, out, damned spot" line for which she is famous. She shortly commits suicide.

In an early attempt at camouflage accessorizing, Malcolm decides that the army may be able to hide its movement if his soldiers each carry a tree branch while they cross the plain. When Macbeth hears that Birnam Wood appears to be moving toward Dunsinane, he understands that the witches' latest counsel was, in fact, prophecy. He knows that his fate is upon him but prepares himself to fight.

During the battle, Macduff finds and engages Macbeth, eager to avenge the death of his wife and family. Macbeth mocks him and says that he cannot be killed by any man born of woman. Macduff replies that he was "untimely ripp'd" from his mother's womb (cesarean!). Now alerted to the small-print surgery clause in the witches' omens, Macbeth realizes that he has been undone by his ambition and the evil play of creatures of the underworld. The two warriors fight, and Macduff kills Macbeth. Carrying Macbeth's head, Macduff salutes Malcolm as the true king of Scotland.

The Scottish Play

The theater is filled with some of the most superstitious people in the known universe. It's bad luck to say "good luck" to performers, and it's also bad luck to say "Macbeth" anywhere near the theater. Generally, the "Scottish play's" curse has been a dressing-room caution, but to be on the safe side, just don't say the name anywhere near where the play is being performed. And don't quote lines from the play near the theater, either.

Things just seem to go wrong at performances of Macbeth. Perhaps it's the supernatural tone of the play that breaks the fourth wall. And Scotland itself, with its dark crags, eerie bagpipe music and people with "the sight," has a spooky reputation. Or maybe the ghost of the real King Macbeth doesn't approve of the spin Shakespeare put on his ascent to the throne.

Whatever the reason, when you add up the mishaps, it sounds like a lot has gone wrong even from the play's very first performance, when the boy who was cast as Lady Macbeth died backstage. There have been other deaths, but mostly it's mishaps. When told all together, these "accidents" sound like a farcical comedy. But just to play it safe, leave the M-word at home when you attend the Scottish play.

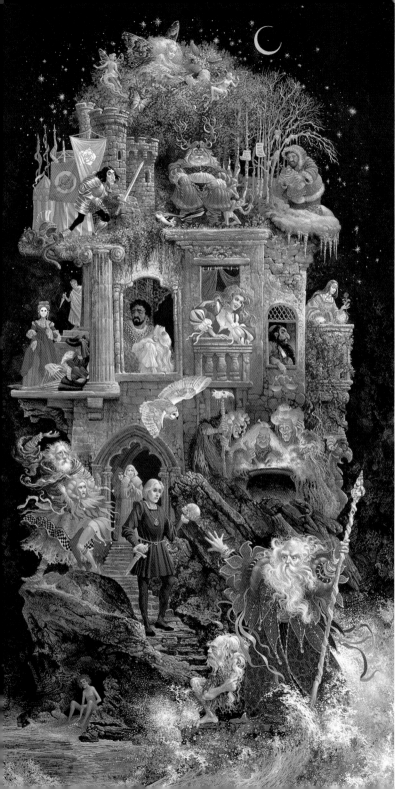

1. Titania, *A Midsummer Night's Dream*
2. Richard III, *Richard the Third*
3. Sir John Falstaff, *The Merry Wives of Windsor*
4. Forest of Arden, *As You Like It*
5. Old Shepherd and Perdita, *The Winter's Tale*
6. Antony's Helmet, *Antony and Cleopatra*
7. Brutus, *Julius Caesar*
8. The Princess of France and Ferdinand, *Love's Labour's Lost*
9. Othello and Desdemona, *Othello*
10. Katharina, *The Taming of the Shrew*
11. Shylock, *The Merchant of Venice*
12. Juliet, *Romeo and Juliet*
13. King Lear and the Fool, *King Lear*
14. Duke Vincentio and Isabella, *Measure for Measure*
15. Hamlet, *Hamlet*
16. The Three Witches, *Macbeth*
17. Timon, *Timon of Athens*
18. Prospero and Caliban, *The Tempest*

THE FIRST TETRALOGY

RICHARD THE SECOND

Many deeds are planned throughout *Richard the Second*, but few of them (except that nasty bit at the end where the imprisoned king is murdered) are completed. This is reminiscent of the U.S. Congress—the inactivity, not the murder—except that *Richard the Second* is written wholly in verse, giving it a rhetorical beauty suitable to a king's downfall and death.

King Richard is in love with the pomp of his office and the idea of the divine right of monarchs. Compared to the pragmatic, down-to-earth Henry Bolingbroke (later Henry IV), Richard seems more the *image* of a king, than a king himself. The play is also a portrait of the times. Richard II was the last true medieval king, embodying divine right and the rules of chivalry. Henry IV's reign marked the start of an era when secular concerns began to limit the power of the church.

The play begins with Henry Bolingbroke accusing Thomas Mowbray of participating in the duke of Gloucester's murder. The two plan to duel, which the king tries to prevent. When neither gentleman will accede to the king's wishes, he banishes them both: Mowbray for life and Bolingbroke for ten years. Bolingbroke's father, John of Gaunt, pleads with the king not to banish his son. The king reduces the sentence to six years, but John of Gaunt will not live to see his son's return.

When Gaunt dies, the king seizes his estate (and banishes Bolingbroke for life) so he can lead an army to Ireland and put down a rebellion. Gaunt's brother, the duke of York, tells the king he is wrong, but the king doesn't pay him heed. Richard goes off to Ireland.

Henry Bolingbroke leads an army into England, and the duke of York isn't pleased with him either and tells him so. But the duke of York is in no position to fight a war (the army being in Ireland with Richard). Rumors fly that Richard hasn't been heard from and may be dead. As quick as you can say "regicide," Henry Bolingbroke is all but running the country.

Richard returns from Ireland and his army disperses. He and his followers are at Flint Castle when Bolingbroke's army

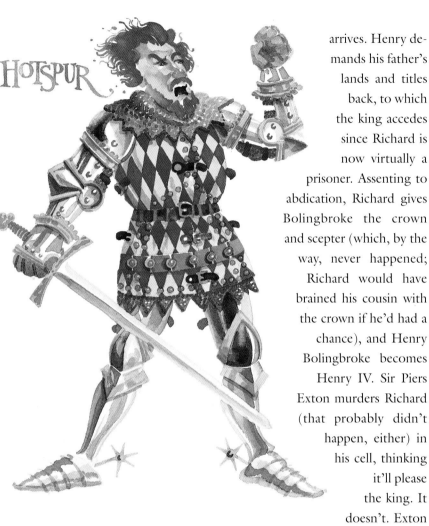

HOTSPUR

arrives. Henry demands his father's lands and titles back, to which the king accedes since Richard is now virtually a prisoner. Assenting to abdication, Richard gives Bolingbroke the crown and scepter (which, by the way, never happened; Richard would have brained his cousin with the crown if he'd had a chance), and Henry Bolingbroke becomes Henry IV. Sir Piers Exton murders Richard (that probably didn't happen, either) in his cell, thinking it'll please the king. It doesn't. Exton is renounced, and the play ends with the king, declaring a crusade to the Holy Land to assuage his guilt.

HENRY THE FOURTH

In contrast to *Richard the Second*, *Henry the Fourth* juxtaposes the powerful world of the king and his nobles with the common milieu of his subjects. Tavern scenes are intermixed with scenes at court.

The crusade is postponed in order to deal with rebellion in Scotland and Wales. The good news is that Henry Percy, known as Hotspur, has routed a rebellious band of Scotsmen in the name of King Henry. The bad news is that Welsh rebels have defeated and captured one of Henry's nobles, Edmund Mortimer. The good news is that Henry doesn't want Mortimer anyway. The bad news: Hotspur hasn't turned over his prisoners to the king.

King Henry's son Henry, Prince of Wales, is blissfully unconcerned. He is content to drink, wench and consort with unsavory companions like Sir John Falstaff. While King Henry struggles with rebellions, Prince Hal, Falstaff and their drunken friends plan highway robbery. But once alone, Prince Hal muses about the day when he will take on the mantle of leadership. He knows he cannot remain a wayward boy forever.

Hotspur has begun to see King Henry as a usurper whose supporters—Hotpsur himself, his father and many other nobles—assisted his rise to the throne only to see him abandon them all. The rebels meet and attempt to form an alliance.

As the prince plays a jest on Falstaff at the tavern, a messenger from the king commands Prince Hal's pres-

ence in court the next day. Henry questions his son's loyalty. Hurt, Hal vows to end his profligate life. He also plans to fight Hotspur. When the king and Prince Hal learn that the rebels are encamped at Shrewsbury, King Henry begins plans for a battle. Prince Hal and his brother, John of Lancaster, will each lead an army.

At Shrewsbury, King Henry offers to negotiate peace. Sir Vernon and the earl of Worcester go to the king. The king offers amnesty, but the two politically savvy men don't trust the king. They decide not to tell Hotspur of the amnesty offer.

The battle rages and, just as King Henry is on the point of being killed by the earl of Douglas, Prince Hal enters and dispatches the rebel. The king leaves and Hotspur enters. Falstaff, hidden nearby, watches them fight. Challenged by another knight, Falstaff takes a dive and feigns death. After killing Hotspur, Hal says words of admiration for his dead foe. Hal also says a few casual words over his "dead" friend Falstaff. Once Hal is gone, Falstaff arises and stabs the dead rebel. Upon his return with other companions, Prince Hal doesn't challenge Falstaff's ludicrous claim of killing Hotspur.

The play ends with King Henry preparing to hunt down the remaining rebels, having just had Vernon and Worcester executed. The two gentlemen were indeed correct that the king's wrath would fall heavily on them, though the pleasure of being right was extremely short-lived.

* * * * *

In the second part of *Henry the Fourth*, the civil war continues. Three of the remaining rebels—Lord Bardolph, Travers and Morton—meet at the home of the earl of Northumberland, Hotspur's father. The earl rages over his son's death. The other conspirators talk of the archbishop of York. who has raised an army to retaliate for Henry's usurpation of Richard's throne.

In a tavern, Falstaff continues his dissolute but witty ways, though there is now a manipulative edge to his speeches. He sends a letter to Hal, hoping to play upon their past relationship.

King Henry falls ill again with the sickness and melancholy that have plagued him throughout his reign. Prince Hal tells a companion that his reputation is so sullied that he cannot even mourn his father's illness because it would be seen as hypocrisy.

The rebels join the archbishop, who is deciding when to attack Henry's armies. They plan at first to wait for Northumberland, but the archbishop says they should strike while the tide of public opinion goes in their favor. At

Those Poor Bastards

As if it weren't tough enough for the illegitimate to get a break in Elizabethan England, Shakespeare had to go and use them as handy villains. Don John, the illegitimate brother of Don Pedro of Aragon in Much Ado about Nothing, plots against the happiness of the lovers Hero and Claudio. There's no revenge here, and no mad jealousy. Don John is being mean just for sport. He is, he says, "a plain-dealing villain."

Edmund, illegitimate son of the earl of Gloucester from King Lear, plots against his legitimate half-brother, betrays his father, seduces Lear's daughters Goneril and Regan, and has Lear's youngest daughter, Cordelia, murdered. Illegitimate children were known as "natural" sons or daughters. When Edmund says that "Nature" is his goddess, he's talking about both being a natural son as well as having a nature more pagan, i.e., unredeemed by Christianity. Such a person can be counted on to do the wrong thing.

As villains, they aren't well-developed characters. Their greed and envy seem shallow, but that was enough. If one asked why these fellows were despicable, the answer "Why, he's a bastard" made perfect sense to Shakespeare's audience.❧

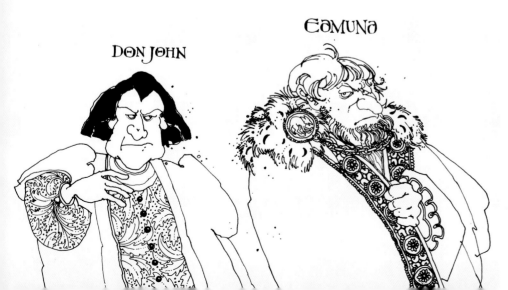

DON JOHN

EDMUND

Northumberland's castle, Lady Northumberland and Lady Percy, Hotspur's widow, counsel the old man not to fight. Why should he help these men when he didn't help his own son, asks Lady Percy. Chastened, Northumberland agrees to flee to Scotland.

Hal goes to the tavern and, pretending to be a serving man, overhears Falstaff insulting him. When Hal challenges the old knight, Falstaff turns the prince aside with witticisms. A messenger comes to tell the prince that the armies are preparing to fight the rebels. Hal is contrite over being with low company when his father needs him. Falstaff is also called to arms though, as with previous battles, he plans to make money from men who buy back their conscriptions.

The archbishop and the other rebels meet in Gaultree Forest. John of Lancaster, Prince Hal's younger brother, meets with the rebels and agrees that their grievances will be heard. They disperse their armies, and Lancaster, in a move that could make a contract attorney blush, takes the rebel leaders prisoner to be later executed.

The king falls deathly ill and his two younger sons, the dukes of Gloucester and Clarence, attend him. Henry is told that Hal is again with his drunken friends in London, and the king mourns the life his heir is leading. A messenger arrives to tell of the

rebels' defeat, but the king weakens still further. When Hal arrives, the king is abed and asleep. His brothers leave him to watch the king.

There's a little contretemps when Hal looks at the king and thinks he has died. He picks up the crown and wanders away. The king wakes up and is aghast at the thought that his son is in a hurry to get rid of him. Hal explains himself, and the king gives him the manipulative (but useful) deathbed advice to make foreign war in order to get the country back on his side.

When the king dies, many of his nobles are concerned that Prince Hal will prove to be as dissolute a king as he was a youth. But Hal surprises them all by showing good sense in decision making. At Hal's coronation as Henry V, Falstaff attempts to play on his familiarity with Hal. But other than allowing the old man a pension, Hal no longer permits Falstaff or his friends nearby. The old knight is banished from London, and the new king puts on the mantle of state.

HENRY THE FIFTH

Henry V is a wholly different man than was the unruly prince. He is ready to take his father's advice to make foreign war. The archbishop of Canterbury and the bishop of Ely search through legal documents in order to give Henry some legal defense for a declaration of war on France. (In the past, much of France had been possessed by England.)

Before the archbishop can offer Henry a large sum of money for the proposed war, a French ambassador arrives. The ambassador has brought an insulting gift (tennis balls, a kind of royal raspberry at the prince's gaming past) from the dauphin (the title given the king's son and heir apparent in France), and the message to Henry is that he's claimed a lot more of France than he has the right to. So Henry, who may have used up his sense of humor while drinking sack with Falstaff, declares war.

A soldier has verbally assaulted Henry. Henry pardons the man, telling his advisors that the man

St. Crispin's Day Speech

He that outlives this day, and comes safe home,
Will stand a tip-toe when the day is named,
And rouse him at the name of Crispian.
He that shall live this day, and see old age,
Will yearly on the vigil feast his neighbours,
And say 'To-morrow is Saint Crispian:'
Then will he strip his sleeve and show his scars.
And say 'These wounds I had on Crispin's day.'
Old men forget: yet all shall be forgot,
But he'll remember with advantages
What feats he did that day: then shall our names.
Familiar in his mouth as household words
Harry the king, Bedford and Exeter,
Warwick and Talbot, Salisbury and Gloucester,
Be in their flowing cups freshly remember'd.
This story shall the good man teach his son;
And Crispin Crispian shall ne'er go by,
From this day to the ending of the world,
But we in it shall be remember'd;
We few, we happy few, we band of brothers;
For he to-day that sheds his blood with me
Shall be my brother; be he ne'er so vile,
This day shall gentle his condition:
And gentlemen in England now a-bed
Shall think themselves accursed they were not here,
And hold their manhoods cheap whiles any speaks
That fought with us upon Saint Crispin's day.

—HENRY THE FIFTH, ACT IV, SCENE 3

was drunk and therefore not culpable. His companions, the earl of Cambridge, Henry Scroop and Thomas Grey, counsel the king to be harsh with insubordination. The king then reveals that he knows these three are plotting treason. They ask for compassion, but he sends them to be executed. Presumably they were sober.

In France, an ambassador offers several dukedoms and Princess Katharine as a wife. Henry lays siege to the town of Harfleur. Henry shouts to the town in bloody detail how, if they have to attack the town, his soldiers will treat the citizens, right down to the babies. The town fathers decide that an appeased soldier is better than an angry soldier, and they surrender.

Henry leaves an occupation force in the town but doesn't allow his soldiers to loot the town or assault the citizens. The French king sends an enormous force against the English. The English force is weary and not, the French think, really able to give battle. They expect the English to pay ransom rather than fight.

At Agincourt, Henry gives his St. Crispin's Day speech and leads his small force against the much larger French army. They beat the heck out of the French (which had more to do with English longbows than Henry's talents), the French king accedes to all of Henry's demands, and Henry marries Katharine. It ends on a high note, except that the epilogue talks about Henry and Katharine's son Henry VI, who's going to lose everything his father just won.

THE SECOND TETRALOGY

HENRY THE SIXTH

If you're used to getting political news as sound bites, *Henry the Sixth* (all three parts of him) is going to be tough to watch. To begin with, everyone's related—it's like going to a Mafia family reunion. Secondly, everyone keeps changing sides.

Henry VI starts the play as a young boy, so he has no lines. Everybody around him is an ambitious scoundrel, and they all wrangle like starved dogs. The French are sneaky; Joan of Arc is a harlot or a witch, and the only really good guys are the English soldiers.

The play begins at the funeral of King Henry V, where a messenger brings news that those blasted French are at it again, trying to take control of their own country. The dauphin (French prince) has had himself crowned king.

At Orleans, the French gain ground and insult the English; then the English drive back the French, who get wimpy and are planning to run away. The Bastard of Orleans (a good bastard, though French) tells them to toughen up and then introduces them to Joan of Arc, who proves herself to the dauphin by beating him in a sword fight. Also, she has an army, which every girl should have if she wants to be taken seriously.

In England, the wrangling goes on. Gloucester (the king's uncle) and Winchester (the king's great-uncle) each want control of the Tower. The Lord Mayor stops their quarrel, but not their feud.

At Orleans, a good knight, Talbot, is exchanged for a French prisoner of war, goes back to the fray and ends up fighting Joan. They fight to a draw, and she runs off to do more damage with the French troops. A French countess tries to capture Talbot with a sneaky little (French) seduction, but Talbot has a clever (English) response: armed men waiting to rescue him at a horn call.

In England, the wrangling goes on some more. Richard Plantagenet (a York) argues with the duke of Somerset (a Lancastrian). Plantagenet plucks a white rose as his emblem and tells all his supporters to carry one, too. Somerset picks a red one and his supporters do likewise, and the War of the Roses is in the making. A dying and imprisoned relative tells Plantagenet that their line has a better claim to the throne. (But they all say that. If you look at the royal family tree, it's as tangled as ivy.) Plantagenet decides to ask the king (a Lancastrian) for the title Duke of York.

Winchester and Gloucester continue their wrangling in the presence of the boy king, who pleads with them to be friends. They agree while everyone's watching. The king gives the title York to Richard Planta-

genet, and the fighting goes on in France. Joan and a few soldiers get into Rouen by posing as tradesmen (more sneaky French stuff). The white-rose/red-rose confrontations get worse, and young Henry goes to France to be crowned king of France (even though the dauphin has taken that title for himself).

The fighting goes first one way, then another. Talbot and his son die in battle when the rose feud results in supplies and cavalry not arriving in time. Henry is betrothed to the earl of Armagnac's daughter. Joan of Arc raises friends, but they desert her. She is captured and sentenced to be burned. She denies her shepherd father, saying she's noble. Then she says she's pregnant, changing the name of the father several times, but they decide

to burn her anyway so she curses the English. The earl of Suffolk captures Margaret, daughter of the poor duke of Anjou. Suffolk is already married but tells Margaret that if she'll be his lover, he'll get the king of England to marry her. She and her father agree. Suffolk closes the play saying, "Margaret shall now be queen, and rule the king;/But I will rule both her, the king, and realm."

* * * * *

Well, here's a fine mess. As Part Two begins, King Henry has discarded his betrothal to the daughter of the earl of Armagnac (who would have paid a nice dowry) and married Margaret of Anjou, whose father, in giving her, got back Anjou and Maine. This nice marital treaty was devised by Suffolk, who is the new queen's lover. For his fine work, the king makes him a duke.

The Lord Protector, also known as Humphrey, also known as the Duke of Gloucester, is not impressed and says so (once the king is out of hearing), then leaves in a huff. The other nobles—the cardinal, Salisbury, Warwick, York, Somerset and Buckingham—each have their own take on the new developments. The cardinal says the Lord Protector wants the crown for himself and would be unhappy even if the new queen's dowry were an empire.

Somerset, Salisbury and Buckingham agree with the cardinal while he's in the room. When he leaves, they comment on the cardinal's pride and say that Humphrey is a noble man. Warwick is unhappy about losing Anjou and Maine because he fought and won the land for England and has the scars to prove it. When everyone's gone but York, he complains that the land given to the duke of Anjou would have been his as the duke of York.

York convinces Warwick and Salisbury that he has legitimate claims of the throne but that they must keep this secret until the duke of Gloucester can be gotten rid of. And happily, Gloucester is shortly murdered by assassins sent by Suffolk.

Suffolk is suspected and challenged to a duel by Warwick, but before this can take place, a mob comes to the gate. They want Suffolk dead or out of England. The king capitulates and banishes the duke. Suffolk and the queen part tearfully and at great length. Suffolk doesn't get far; he's captured by pirates. One takes objection to his having had Gloucester murdered (obviously a very politically acute pirate) and they cut off Suffolk's head.

York is given an army to lead and goes off to keep the Irish in line. Meanwhile, back in the realm, the rest of France has been lost, and the king decides this must be God's will. York is really annoyed with this, France being important to the house of York, and he blames Somerset, the regent of France, for the loss.

A mob of commoners rebel under Jack Cade (put up to it by York), who claims he's a Plantagenet and declares himself the real heir to the crown. He has a clerk executed for being literate, wants the city foun-

tain to flow wine and orders that he be called nothing but Lord Mortimer. A soldier who hasn't heard the order is murdered when he asks for Jack Cade.

The queen runs around with Suffolk's head, carrying on and weeping. The mob is attacking the Tower, killing nobles right and left and generally running amok. The king is dithering and whining about what will become of them all. But just in the nick of time, Lord Clifford speaks to the mob, offering amnesty for anybody who will be loyal to the king. Jack Cade tries to counter this, but Clifford succeeds in swaying the mob to the royal standard.

York comes back from Ireland and insists that Somerset be imprisoned. The king agrees to this, but later York sees that Somerset is still free. York declares *himself* king (and he has that nice army to back this up), but he's opposed by Clifford. York kills Clifford on the battlefield; then Somerset is killed. The king and queen flee to continue the battle another day.

* * * * *

Now you'll have to get used to a whole new crop of nobles. The Clifford in Part Three is the son of the Clifford who just got himself killed. There's a new Somerset, too, because Richard, the third son of Richard Plantagenet, enters this play with the head of the old one.

So Richard Plantagenet, Duke of York, has had

himself named king. He is supported by Warwick and Salisbury, as well as his three grown sons, Edward, who'll become King Edward IV; George, the duke of Clarence; and Richard, the duke of Gloucester.

York and King Henry's faction meet, and York makes his claim based on the usurpation of Richard II's throne by Henry IV, the king's grandfather. This Henry makes a deal with York that if York lets him live out his reign, he can be his successor. York agrees. Queen Margaret has a fit about that, because her son, Edward, Prince of Wales, has just been disinherited.

York's sons convince him that breaking his word to a usurper is no big deal, at which he's delighted. There's a battle at Wakefield, where York's youngest son, Rutland, is captured by Clifford. York begs for his son's return, but Clifford kills him in retaliation for his father's murder. Lord Clifford's men carry the day, kill York and put his head on the gate (decorating has come a long way since then, thank heaven).

At the ensuing parlay, Edward (York's son, not Henry's) demands that Henry kneel to him, because *he* is king. The queen and Lord Clifford say hang on a minute, you varlet, and everyone ignores Henry. They call each other names, and it begins to sound like parents at a Little League game.

Henry, Margaret and their son escape the battle, but Clifford is killed. York's head is removed and Clifford's head gets put on the gate next. (A fresh head is always best, as any fine decorator can tell you.) Mar-

garet and the prince make it to France, but King Henry is caught and put (where else?) in the Tower.

So Edward, York's oldest son, becomes king. There's a bit of a contretemps when he sends Warwick off to get him the French king's sister-in-law as a wife and then decides to marry Lady Elizabeth Grey instead. Warwick goes over to Margaret's side to save his honor, and the French king sends his army to save his.

Warwick and company break King Henry out of jail, and then King Edward gets captured but he's rescued by his brother Richard. Now Richard, as you'll see, is not quite the loving brother you might think. He wants his brother on the throne in order to make it easier for himself to settle there.

Like very poor chess players, Warwick and the others misplace King Henry, and he's captured once again. Warwick dies in battle, and Margaret and her son are captured. Prince Edward insults his captors and gets himself stabbed to death as a reward for his wit.

Richard visits King Henry in his cell, and King Henry curses Richard and predicts ruin for him and his family (again with the insults!), so of course Richard stabs him to death and makes a little speech to himself that his gift for villainy will put him on the throne.

Edward IV, now unimpeded, achieves the throne, and his wife gives birth to a son. He's happy in his new status. But there's Richard off in the corner. Oh, Richard, you fiend, you're there waiting for an opportunity, aren't you?

She Was Matchless but They Burned Her Anyway

In 1431, the nineteen-year-old Joan of Arc was burned at the stake. We know her now as a brave martyr and, since 1920, a Catholic saint. But in Shakespeare's England, she was a villainous interloper who helped steal France back from England's rule. (Think about how China feels about the possibility of losing Tibet.)

In Henry the Sixth, Part One, Joan raises a fiendish army and engages in sneaky (French) tactics. Besides, her virginity is suspect. Facing death, she claims first that she's chaste and will seek revenge at heaven's door. When that doesn't work, she says she is pregnant and gives the name of first one and then another nobleman as father. This all made for great stage drama, and the allusion to witchcraft made Joan's burning at the stake acceptable to the English (who usually preferred hanging or beheading).

The propaganda of the day was outlived by the legend. Most of us know who Joan of Arc was, but who remembers Henry VI? ("He wasn't the one with all the wives, was he?")

RICHARD THE THIRD

Enter Richard, alone. Crook-backed, ill-visaged, so rudely formed that dogs bark at him. And he speaks:

> *Now is the winter of our discontent*
> *Made glorious summer by this son of York*
> *And all the clouds that lour'd upon our House*
> *In the deep bosom of the ocean buried...*

Their side has won. The Yorks are victorious over the Lancastrians, and there is peace in England. But Richard is not happy. He is not made for love or dancing, so he is determined to prove a villain:

> *...Plots have I laid, inductions dangerous,*
> *By drunken prophecies, libels, and dreams...*

His first victim will be his next older brother, George, duke of Clarence. Nothing personal, it just puts Richard a step closer to the crown. King Edward, who is ailing, fretful and paranoid, falls right in with Richard's plotting.

In all this he's speaking to himself, and we the audience overhear like eavesdroppers. We're drawn into his plotting just as are his temporary allies and foils, but only momentarily, because Richard truly is alone. Even his mother dislikes him. But if we cannot like him, we do feel some strange fascination and admiration. He is such a witty villain. He says of his imprisoned brother:

> *...Simple, plain Clarence, I do love thee so*
> *That I will shortly send thy soul to Heaven—*
> *If Heaven will take the present at our hands...*

The play proceeds like a lethal game of Family Feud. "Survey says: Off with his head." First to go is brother George, the Duke of Clarence, as Richard has predicted. He's taken off to the Tower by the king's order because a prophecy says that King Edward's heirs will be slain by "G." Of course, there's another "G," namely Gloucester, who is our own villainous Richard, but no one seems to think of that. Yes, George of Clarence has to go, but first Richard needs a wife of royal blood. He decides on Lady Anne, wife of the late Prince of Wales, daughter-in-law to Henry VI. Since both these gentlemen were killed by Richard, this will be quite a coup.

Richard accosts Anne at the side of King Henry's corpse, where she does her best to insult and scorn him for killing her husband and father-in-law. Richard counters that the cause of their deaths was her beauty,

that he loved her so well that he killed her husband so he could have her. He pulls his sword, gives it to her and tells her to kill him. She refuses, so he tells her to bid him kill himself. She cannot. Like a snake hypnotizing a mouse, Richard bewitches Anne with words. He gives her a ring in earnest of their plan to marry.

And after she leaves, he crows:

Was ever woman in this humour woo'd?

Was ever woman in this humour won?

I'll have her, but I will not keep her long...

Another fly in the ointment is the queen. She, her brother Lord Rivers and her two sons by her first marriage, Lord Grey and the Marquis of Dorset, are no friends to Richard. They are in the process of a vicious family quarrel when Queen Margaret, Henry VI's widow, comes in and curses them all, most especially Richard. When she leaves, Richard, with the pure calculation of a devil, tells everyone he feels sorry for her and regrets that he has caused her harm. Everyone says, "What a nice Christian attitude," and as soon as he can get away, he sends a couple murderers to visit Clarence in the Tower. King Edward had signed a death warrant for poor George but later thought better of it and countermanded the order. Richard simply makes certain the first order gets carried out before the second arrives.

King Edward, still ailing, insists that everyone reconcile. Everyone agrees (yeah, sure), and the queen asks the king to reconcile with his brother George.

Will the Real Richard III Please Stand Up ... Straight

The fictional character of Shakespeare's Richard III is a superb villain. He doesn't just do a few bad things; he walks right up to the audience and tells them that he chooses to be evil. His body is twisted, hunched, withered, the outer mirror of his inner awfulness. From the stage, this character captures our imagination as an embodiment of evil.

Richard III of England was almost certainly neither crippled nor evil, and probably no worse a king than many. Without a doubt, he was a better regent than the more obvious miscreants like Henry VIII.

Shakespeare would have been ill-advised, however, to any anything negative about Henry VIII, or his father Henry VII (who took the crown from Richard III), since they were father and grandfather to Queen Elizabeth herself.

Pleasing the queen was the first commandment for playwrights in Shakespeare's day. In his defense, William Shakespeare the actor/playwright didn't know he was going to be SHAKESPEARE, so he can be forgiven for being a sixteenth-century spin doctor. ❧

Richard tells them that George is dead, that the order to kill him had already been carried out when the countermand arrived. Conscience-stricken, Edward berates his family and the courtiers, none of whom pleaded to save his brother's life.

The king dies and his queen is nearly in hysterics, grieving for her husband, worrying over her sons and family. Her mother-in-law, the duchess of York, comforts her, though she herself is mourning the loss of two sons. When Richard arrives, he plays the mourner and also asks his mother's blessing. She replies,

God bless thee, and put meekness in thy breast;
Love, charity, obedience, and true duty.

All of these might be read as criticisms of Richard's character, and he points out in an aside that she omitted a wish for his long life.

Lord Rivers suggests that the Prince of Wales be sent for and brought to London, and a group of his mother's relatives go to meet the boy. Richard, aided and accompanied by the duke of Buckingham, also attends, hoping to insinuate themselves between the boy and the queen's people. A group of citizens gather and discuss the state of the kingdom, which has them worried.

The queen receives news that a number of her supporters have been rounded up and imprisoned. She plans to enter a church with her son for sanctuary, but this is not to be. Richard meets the young prince and tells him that, for his own safety, he and his brother will be settled in the Tower. The Prince of Wales doesn't like the sound of that—and small wonder, since people have a way of meeting untimely ends there.

Once the two little princes are in the Tower, Richard's henchmen, Catesby and Buckingham, go about trying to convince the Lord Chamberlain, Hastings, to have Richard crowned king. Buckingham wants to know what they should do if Hastings is recalcitrant. Richard replies, "Chop off his head, man; somewhat we will do." Richard then offers Buckingham the earldom of Hereford for his assistance, telling Buckingham he'll get his reward once Richard is king.

In short order, Richard has gotten rid of Hastings by accusing him of being involved in a plot against himself, aided by Hastings's mistress, a supposed witch. Then his fellow conspirators cast aspersions on the legitimacy of Edward's sons. In a very nice bit of artifice, Richard gets the Lord Mayor of London and a group of nobles to beg him to take the crown in order to stabilize the country.

Lord Stanley visits Elizabeth, former queen, and Anne, soon to be queen with her husband Richard's coronation. He tells them what's afoot: that the princes in the Tower cannot be visited by anyone and that Richard will be king. The earl of Richmond is living abroad (if he'd been around, Richard would have had him killed before you could say "knife wound"), and Elizabeth sends her son Dorset to him.

Poor Richard. He's like a dog that chases cars until

he actually catches one. Then what? As a conspirator, a plotter, a behind-the-scenes mover and shaker, Richard is extraordinary. He makes things happen. But as a king he's less successful. Oh, sure, he engineers his wife's death and the death of the two imprisoned princes—nice touches both—but he loses the support of Buckingham when he refuses him the earldom of Hereford that was earlier promised for Buckingham's help.

Right and left, people are flying to the side of the earl of Richmond, and Richard is incensed. He knows that Richmond would come closer to the crown by marrying Elizabeth's and Edward IV's daughter, also named Elizabeth, so he meets with the widowed Elizabeth and proposes that he himself marry the young woman. Elizabeth wants to know why she should agree to this when Richard has already killed her two sons by Edward, as well as her brother. But she pretends to let him argue her into an agreement. Then she and her daughter hightail it for Richmond's camp.

Richmond's forces are on the move and Richard goes into high gear, but not with his usual effectiveness. The fleets of the two rivals are separated by a storm, but Richard's forces do capture Buckingham, who is executed.

The opposing armies march to Bosworth Field. Lord Stanley would like to defect to Richmond, but Richard is holding his young son hostage. Stanley meets with Richmond and tells him that he will at least delay his forces in the coming battle.

Who's on First?

It's bad enough that all of the kings of England seem to have been named Henry, Richard or Edward, with surnames, titles and nicknames from their pre-king days, but everyone else seems to have had three or four names and titles, and too many of those people are also named Henry, Richard and Edward.

In Richard the Second, the king banishes Henry Bolingbroke, the duke of Hereford (also called Harry of Hereford), the son of the duke of Lancaster, John of Gaunt, which also makes him a Lancastrian. When John of Gaunt dies, Richard takes his lands and titles. Harry/Henry/Bolingbroke rebels to get his father's title back so that he can also be the duke of Lancaster, but why be a duke when you could be king? So Harry/Henry/Bolingbroke gets the Percys—Henry Percy, the earl of Northumberland, his son Henry Percy, later known as Hotspur—to help him win the crown. The Percys don't think Henry IV is properly grateful.

Henry IV has to fight a rebellion from the Percys, but Henry IV's son Henry, Prince of Wales, called Prince Hal, kills Henry Percy (Hotspur, not the earl). Later, Prince Hal, now called Henry V, pardons Henry Percy (Hotspur's son, not his father), so he keeps the title of earl of Northumberland to pass on to his son (what else?) Henry Percy in Henry the Sixth, who passes the title to his son (you guessed it) Henry Percy, who is the earl of Northumberland in Richard the Third.

91

Richard goes to bed and falls asleep, and the ghosts of all the relatives and sundry he's had murdered come to haunt him. They're a cheerful bunch, each one telling him to despair and die. He wakes up in torment but recovers enough to get ready for battle.

In the battle, he is unhorsed and shouts, "A horse! A horse! My kingdom for a horse!" which is a terrific line but doesn't help him to win a sword fight with Richmond, who kills him and becomes Henry VII.

Reality Check, Please!

Richard II (b. 1367, d. 1400) became king as a ten-year-old boy but didn't take control of the throne until he was twenty-two, a situation that left his uncles in charge of the country for many years. Although Richard II wasn't a great king, a lot of his fall was caused by bad advice and treachery. Piers Exton probably didn't murder him, though it is possible that he was starved to death in the Tower.

Henry IV (b. 1366, d. 1413) was a hard-headed and pragmatic man who suffered few or none of the pangs of conscience Shakespeare gave his stage counterpart. He died at age forty-four of an illness that assailed him for the last year of his life—not, as Shakespeare had it, for most of his reign.

England's triumph at the battle of Agincourt had less to do with Henry V's (b. 1387, d. 1422) leadership than with the killing power of the English longbow. Listening to the St. Crispin's Day speech, one would expect this king to go on forever. But he reigned a scant nine years and only lived to be thirty-five. He probably died of dysentery or a similar internal disorder, though the French hoped it was divine retribution.

Henry VI (b. 1421, d. 1471) became king at the age of one. There were notable events during his reign, particularly the loss of France and the War of the Roses. In the 1450s, he was catatonic for a couple years during which a regent ran England. Edward IV took the throne in 1461, but Henry briefly regained it in 1470 before being captured and, shortly thereafter, murdered in the Tower.

Edward IV (b. 1442, d. 1483) didn't get his own play. In fact, watching Richard the Third, *you'd think Edward was only on the throne for a few months, but he actually reigned for twenty-two years. He was a lusty man whose appetite for wine, women and song probably shortened his life.*

Richard III (b. 1452, d. 1485) did seize the throne but may have felt compelled to stop the coups attempted by Edward's widow and her family. He also may have had the young princes killed, but it's equally possible that the earl of Richmond (later Henry VII) had them murdered. Richard's wife, Anne, probably died of natural causes. Richard fell in the battle of Bosworth Field at the august age of thirty-three.❧

HENRY THE EIGHTH

If you're expecting a drama about a king killing off a bunch of wives, you'll be disappointed. The term of this play progresses from shortly before Henry's divorce from Katharine of Aragon to the birth and christening of his daughter, Elizabeth. The play is full of politicking, a little like watching clips of the best of sixteenth-century C-Span.

Henry the Eighth begins with Cardinal Wolsey (yes, a Catholic, so you know he's not to be trusted) who has just made a treaty with France that was disadvantageous to England. (In Shakespeare's plays, the French are almost always sneaky.) The duke of Buckingham takes issue with the treaty, but Cardinal Wolsey is trusted by Henry VIII and Buckingham is arrested. When he goes to be executed, he is so forgiving that you might think he was trying for sainthood.

Wolsey throws a party for the king where Henry meets and falls in love with Anne Bullen (that's Anne Boleyn to us). Anne is a nice Protestant lady-in-waiting. Wolsey is all for Henry getting a divorce, but he wants to fix him up with one of those French girls. Henry never did like being contradicted, so Wolsey gets his comeuppance and is also polite and even sounds thankful en route to execution. King Henry gets divorced and marries Anne; they have a daughter,

and the play ends with a lot of high-minded wisdom.

Shakespeare wasn't dramatizing history in *Henry the Eighth*. The break with the Pope and Catholicism was a huge change for England, and its portrayal required larger-than-life themes and characters. Similar to our story of George Washington crossing the Delaware, *Henry the Eighth* created a cultural myth. And what are a few wives balanced against getting those nasty Papists out of England?

KING JOHN

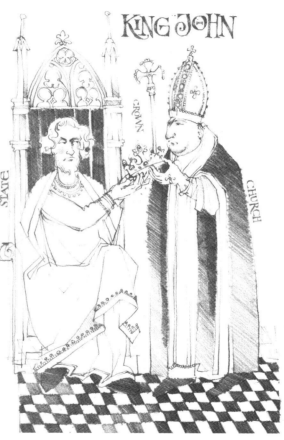

Shakespeare wrote *King John* to make a point about government and political stability. He played fast and loose with historical fact, and not for the first time. Shakespeare also completely left out what is now considered the most historically noteworthy event of John's reign: the signing of the Magna Carta.

King John had everything to do with claims of legitimacy to the throne. As in the ascension of Queen Elizabeth I, there was a question of who was the legitimate heir to King John's throne. His older brother's son, Arthur, was a contender for the throne, in the same way that Mary, Queen of Scots, was a contender for Elizabeth's throne. The Bastard in *King John*, an illegitimate son of the late King Richard, also mirrors Elizabeth's conception outside of marriage as daughter of King Henry VIII

and Anne Bullen (Boleyn).

The main action of *King John* lies in the manuevering of all the interested parties. France at first opposes John, taking Arthur's part and threatening war on England. But then the French king's son, Lewis, marries King John's niece, Blanche, making the French allies with John. King John at first struggles against making the Roman church a higher authority than the English monarch. But then he gives the crown to the Pope's emissary and allows the priest to place the crown back on his head, a symbolic rendering of homage.

The whole point of this drama was that good government led to internal stability and safety from external attacks. The burgeoning merchant class of Shakespeare's day would surely have applauded these sentiments.

THE ROMAN PLAYS

JULIUS CAESAR

Answer: "Beware the Ides of March," and "*Et tu, Brute?*" and "Friends, Romans, countrymen, lend me your ears." Question: What do you remember from your high school reading of *Julius Caesar*? (And frankly, those three quotes pretty much tell the story, except to add that Julius Caesar and Brutus both really ought to have listened to their wives.)

Julius Caesar is a heck of a commander. When he leads an army, he gets stuff done. The problem with being a really good general is that when you get back to civilian life, you might start thinking, "Jeez, if I were the head guy here, I could really whip this place into shape." Your peers may take issue with you wanting to be the boss since the country has been working pretty well with all the aristocrats sharing power. A soothsayer tells Caesar to beware the Ides of March, but since Caesar doesn't read his horoscope, either, and has done pretty well so far, he ignores the omen.

The commoners are all ready to cheer for Julius Caesar, but commoners will cheer for anybody. A group of the aristocrats are worried Caesar's going to end up becoming king. You'd like to think this is because they care about Rome, but basically these fellows are jealous. Some of them, like Cassius, are guilty of taking bribes and other unsavory behavior. Cassius takes Brutus aside and they discuss the problem of Caesar's ambition. But Brutus is a friend to Caesar; he'll need some convincing. Cassius gets some of his co-conspirators to place messages where Brutus will find them. They appear to be coming from a lot of people.

That night there's a terrible storm, which everyone knows is always a portent of something or other. Brutus is sick at heart and his wife, Portia, would like to know what's troubling him, but he doesn't tell her. Caesar's wife, Calpurnia, wants to keep Caesar home on the Ides of March, but he goes out anyway.

Brutus is finally swayed by Cassius's plan and his own misgivings about Caesar's ambitions. Early in Act Three, a group of aristocrats stab Caesar, and he says, "You, too, Brutus?"—in Latin, although the play is in English—and dies.

Mark Antony comes to meet with the group of assassins and tells them he's their friend, and that if

BEWARE THE IDES OF MARCH
THE IDES OF APRIL AREN'T SO GREAT EITHER

they say Caesar was wrong, he's willing to listen. Brutus assures him that once he hears their reasoning, he'll agree with them. Mark Antony asks to speak at Caesar's funeral. Brutus agrees to this, but Cassius is nervous (and with good reason). After they leave, Mark Antony's soliloquy shows that he plans to launch a civil war to avenge Caesar.

At the funeral, Brutus takes great pains to assure the commoners that it was necessary to kill Caesar because of his ambition. Mark Antony then does his speech to his friends, Romans and countrymen, and such is the force of his rhetoric that they do lend him their ears—and their arms. They gather into a mob to attack the assassins. They murder Cinna, the poet, mistaking him for one of the assassins (also named Cinna). The conspirators decide that now is a perfect time to see some other part of the world, and they flee Rome.

Brutus and Cassius raise an army. Mark Antony and the other triumvirs, Octavius and Lepidus, raise an even bigger one. All is not well in Brutus and Cassius's camp. Brutus has had reports that Cassius takes bribes and has also received a message that his wife has committed suicide. Brutus and Cassius patch up their quarrel after learning that Octavius and Antony's army is on the march. Brutus thinks they should march to Philippi, though Cassius would like Antony's army to wear itself out marching. Brutus prevails and that night sees Caesar's ghost who tells him that he'll see him at Philippi.

In Philippi, the ghost appears to Brutus again, and he knows he'll die. Cassius commits suicide when it looks like his forces will be overwhelmed. Brutus's army overcomes Octavius's army, but Mark Antony's army is about to prevail, so Brutus falls on his sword. Even though they were enemies, Mark Antony calls Brutus a noble man and has him buried in state.

ANTONY AND CLEOPATRA

Antony's followers are disturbed that Antony is enmeshed in an amorous intrigue with the Egyptian Queen Cleopatra. After all, he ought to be off soldiering. The politics in Rome and around the empire are falling into chaos while Antony tarries in Cleopatra's arms. A messenger arrives. Cleopatra taunts Antony, saying it could be orders from Caesar, or Antony's wife, Fulvia. This gets Antony hot under the collar (or toga), and he refuses to hear the news.

Eventually, the messenger gets Antony's ear and tells him that his wife's army has been fighting against his brother Lucius, but they have since been defeated by Octavius Caesar. Elsewhere, an upstart general, Labienus, has put together a Parthian army to take over part of the Roman Empire. Another messenger brings the news that Antony's wife has died. Antony says he mourns her now that she's dead,

even though he had wished her dead before she died. (Men. Who can figure out what they want?)

Antony decides he's got to get out of Egypt and away from the delightful but dangerous wiles of Cleopatra. When he tells her, she sulks but eventually wishes him well. Back in Rome, Octavius is pretty disgusted with Antony's behavior. He wants him to toughen up and act like a soldier again. He'd also like him to beat back Pompey, another rebel, who's got a powerful fleet and pirates on his side.

Pompey is in Messina gloating over his odds of beating Octavius, since Mark Antony is still playing house with Cleopatra. A messenger arrives with news of Antony's return to Rome. Pompey's a little less sure of his chances but puts a good face on it.

When Antony gets to Rome, he tells Octavius he had nothing to do with his wife's and brother's rebellion and he agrees to help Octavius stop Pompey. And to cement the deal, he marries Octavia, Caesar Octavius's sister, which is going to fry Cleopatra's liver when she finds out.

Now that Antony's returned to court, Pompey agrees to a truce. Meanwhile, Antony's general, Ventidius, defeats the Parthian army. Antony and Octavia leave Rome for Athens. While Caesar Octavius grieves his sister's departure, Antony and Caesar are glad to be shed of each other. Shortly after she arrives in Athens, Octavia thinks she can mend the breach between her husband and brother if she returns to Rome. Antony

lets her go and then gets himself right back to Egypt, where he and Cleopatra declare themselves rulers in that part of the empire. (This really gets Octavius Caesar's goat.)

Antony's navy loses a sea battle to Caesar when Cleopatra's ships sail away and Antony follows her. Antony writes asking Caesar if he can live in Athens and Cleopatra can remain as ruler of Egypt. Caesar replies that Cleopatra can have whatever she wants if she sends him Antony's head. Caesar copies Cleopatra on the message.

Caesar's forces come to Alexandria, and Mark Antony prepares to fight. Antony's forces win a land battle, but Caesar concentrates his forces in a sea battle. Cleopatra's fleet goes over to Caesar's side. When Antony next sees Cleopatra, he rages over her apparent desertion and she flees. She sends a messenger with word that she's committed suicide, but she's really hiding out in a monument. Antony decides to fall on his sword but doesn't kill himself outright. Cleopatra, worried that he might kill himself, sends

Can You Say "Iambic Pentameter"?

Sure you can. It sounds like a mouthful of marbles, but really all it means is a line of verse with ten syllables, five of which are stressed (no, no, they don't need Valium) and five are unstressed. Iambic pentameter has a singsong quality that resembles how English is spoken. It works like this: la-LA la-LA la-LA la-LA la-LA. Thusly: we DO our WORK exCEPT on DAYS like THIS.

a messenger to say she's still alive. His followers carry him to her. He tells her that at least Caesar won't get a chance to kill him, and he dies.

Cleopatra knows the game is up. Caesar's soldiers disarm her when she tries to stab herself, so she gets someone to bring her a bag of asps. She hugs a couple of them; they bite her, and she dies. Caesar has Antony and Cleopatra buried together as a monument to their great passion.

CORIOLANUS

Don't bother trying to like Coriolanus. He's a fierce, brave soldier, but he's a crashing snob as well as a bore and a bully. He's like a rodeo bull: capable of charging anything that moves, but easily foiled by the wiles of weaker creatures.

Notwithstanding all his military might, he's a mama's boy, unable to proceed in any direction without his mother's approval.

The play begins with a starving mob that calls for the death of Marcius (later Coriolanus), so they can buy corn at a lower price. Marcius's friend, Menenius, quiets the mob. Then Marcius arrives and holds them at bay with his fierceness. Another threat is looming: the Volscians are about to attack, and everyone wants Marcius's help to fight them. Marcius wants to fight the Volscian general Aufidius, whom he has beaten before.

Marcius's wife, Virgilia, is worried about him going to war, but his mother, Volumnia, says she'll get more pleasure if he dies in battle than she had when he was born (she's not a candidate for Mother of the Year).

Marcius and his forces lay siege to the Volscian town of Corioles. The Volscians are beating back the Romans when Marcius charges Corioles alone and runs right into the town. Everyone figures he's a goner, but he rushes right back out with Volscians chasing him. His troops take heart at his bravery. Marcius fights Aufidius again (but he really should have taken the time to kill this guy), and the Romans win.

Marcius is now known as Coriolanus. Menenius chides the tribunes (officials elected by commoners) for hating Coriolanus. Once alone, the tribunes discuss Coriolanus's coming honors but decide they can cross off his ascension to consul, highest office in Rome, because his pride will make him refuse to display his scars,

an important tradition.

Coriolanus does want to skip the exhibition, but the tribunes insist and the aristocrats persuade Coriolanus to do as he's asked. He goes before them and grumpily asks their support, which they give. The tribunes later berate them and get them to agree to take back their approval before Coriolanus can take office.

The mob rises against Coriolanus, who explodes angrily at them, saying they aren't worthy to choose a consul. The tribunes incite the mob. Coriolanus wants to attack them. Menenius convinces the tribunes to try Coriolanus under the law. The aristocrats and Coriolanus's mother persuade him to apologize.

He goes before the people, but the tribunes bait him into losing his temper. The mob declares him a traitor and banishes him from Rome. The Volscians figure this is a perfect time to attack Rome, now that they've tossed their best general out. Coriolanus is really mad and joins the Volscians. He goes in poor man's dress to Aufidius's house and bitterly describes his banishment. Aufidius just about dances to find that he has the great Coriolanus to help him fight against Rome.

His servants are perplexed that he accepts this unknown man so readily, but when they discover that it's Coriolanus they are all set to go to war against Rome. (And of course Aufidius has a conspiracy in mind.)

The Volscians march on Rome, and the Roman general Cominius attempts to meet with Coriolanus but is rejected. Menenius, Coriolanus's friend, also tries to make peace, but Coriolanus won't talk to him either. Finally Coriolanus's wife and mother go and make the plea. His mother makes a long speech about how his honor, which was great, will be destroyed by this act of revenge. Appealing to his pride is exactly the button to push, and Coriolanus makes a peace treaty.

The Volscian commoners are ready to accept peace, but Aufidius sees his chance. He calls Coriolanus a traitor and, what's worse, a boy. Coriolanus rages, and Aufidius turns the mob against him. Aufidius and a group of conspirators stab Coriolanus. Aufidius tells the mob that Coriolanus deserved to die but he was a good soldier, so he should get a good funeral.

THE TEMPEST

You would think that a man who'd spent his life learning magic and enchantment would have known, or at least had an inkling, that his brother was plotting to steal his duchy and set him adrift on a leaky boat. But in this, Prospero is no luckier than the rest of us. When the play opens, he has been a castaway on an island with his daughter, Miranda, for twelve years.

The tempest of the title is the storm that Prospero has conjured to set things right. It will be his last act of magic. Prospero has learned a lesson during his exile: focusing on one thing (no matter how powerful), to the exclusion of all else, is a self-imposed exile from life. But that doesn't mean his perfidious brother shouldn't get some well-deserved comeuppance.

Prospero's storm has overtaken a fleet with a ship carrying Alonso, the king of Naples; his son, Ferdinand; his brother, Sebastian; Antonio, Prospero's brother, the usurper and current duke of Milan; and Gonzalo, one of Prospero's honest, old councilors. The fleet is returning from Tunis where King Alonso has attended the wedding of his daughter. The fury of the tempest centers on the king's ship.

Miranda is distressed to see the ship foundering in the storm and to hear the cries of mariners and passengers as they are thrown into the sea (she thinks) to drown. Prospero assures her that the tempest is of his doing and that no one will die. He then gives her an account of their history, since she was so young when they were set to sea that she has but few memories from before their time on the island. He then charms her to sleep so that he can speak with Ariel, an air spirit and the most overworked but underutilized talent in the history of indentured servitude.

Ariel tells Prospero that he went from place to place on the storm-tossed ship, appearing here as fire, there as lightning until all the seamen and passengers leapt madly into the sea. The rest of the fleet sailed away, convinced by Ariel's arts that the king's ship had gone down. In fact, the mariners and ship are safe in a nearby harbor. Ferdinand, the king's son, has been brought to a place alone, while the other passengers have come ashore together. No one has been harmed, and even their clothing is as good or better than new.

Prospero then sends Ariel to sing as an invisible sea nymph, to charm Ferdinand and lure him to Prospero's house. The enchanter wakes his daughter and they go to the cave that their reluctant servant, Caliban, occupies. Caliban is *such* a charmer, telling father and daughter that the only reason he's glad he learned their

language is so that he can curse them. He is unrepentant about his past attempt to rape Miranda, and says so. Although he knows his cursing and grousing will mean punishment, he cannot help himself. But when Prospero sends him to bring in wood, he goes, because Prospero's magic is too powerful to disobey.

Ariel lures Ferdinand to Prospero and Miranda. The two young people see each other and, as is Prospero's design, fall in love. But Prospero worries that love found and won too easily can as easily be put aside. He accuses Ferdinand of being a spy and commands Miranda not to listen to Ferdinand or plead his case. Well, there's nothing like an irascible and suspicious father standing between two lovers to help new love take root and flourish.

Wandering about on another part of the island are Alonso the king, Antonio the duke, Sebastian the king's brother, Gonzalo the elderly councilor and loyal subject of Prospero, and others from their ship. The king is grieving for his son, Ferdinand, whom he presumes lost. One of the other servants attempts to comfort the king, saying that he saw his son swimming strongly toward shore, but the king remains downcast. Antonio and Sebastian, who are certainly two of a kind, are untouched by the king's grief and spend their time making jests between themselves about the aged Gonzalo.

Ariel enters invisibly and puts a spell on all of them except Antonio and Sebastian so that the group falls asleep. While they slumber, Antonio, in a roundabout way, suggests to Sebastian that they kill the king. The king's heir, he says, is drowned, and his other heir, Claribel, is married far away in Tunis. If the king should die, who but Sebastian would be the sensible choice to become king?

Caliban

Is Caliban a monster? An enslaved aboriginal? A savage? Or just an island native with deviant hygiene? If you play with his name a little, you end up with Canibal. Certainly Shakespeare had heard the tales from travelers to the Caribbean islands and other tropical lands. Their narratives, some true, some not, of strange-looking, barely dressed people who worshipped idols instead of the one true God and sometimes ate their neighbors from nearby islands must have captivated the staid Elizabethan imagination. Shakespeare possessed most of the prejudices of his age: civilization was European, and the very best brand of civilization was English.

In Caliban, Shakespeare created a complex, intense character, not just a comical villain. Caliban is unrepentant about his attempt to rape Miranda.

O ho, O ho! Would't have been done!
Thou didst prevent me. I had peopled else
This isle with Calibans.

He's a bad egg, but there's something there that plucks our sympathy, too. He was alone on his island with no way to continue his line. The desire for kindred is natural to us all. Small wonder that he looked with evil designs on the daughter of the man who has taken over his island and made him a servant. On the other hand, there's something humorous in his grousing:

You taught me language, and my profit on 't
Is that I know how to curse . . .

Caliban might be a miscreant, but Shakespeare gives him a real love of his island. However low a man might be, he can still feel love for his native land. Caliban tells Stephano and Trinculo, who have washed ashore during the tempest:

Be not afeard. This isle is full of noises,
Sounds and sweet airs that give delight and hurt not.

Unfortunately for Caliban, Stephano rides ashore aboard a barrel of sack, a kind of sherry. He introduces Caliban to drink, and Caliban drunkenly makes Stephano his new master. Shakespeare plays this for its comic value, but we find in it a mirror of what happened with the native folk in the New World, who were beguiled by alcohol, robbed of their birthright and introduced to the Europeans' vices and diseases along with their "civilization."

At the play's end, Caliban is left alone, but the island is his own once more, and he is his own master.

CALIBAN

Antonio, who's had practice in usurpation and who has slightly less conscience than a shark, offers to kill the king, if Sebastian will kill Gonzalo. Before they can commit the crime, Ariel breaks the spell and the sleepers awaken. Seeing Antonio and Sebastian with weapons drawn, the king asks why. Sebastian says they heard a roaring like bulls, or rather lions, and Antonio says, yes, a whole herd of lions. The entire party departs, still seeking the king's son.

Elsewhere, Caliban is hauling wood while thunder roars above. The jester, Trinculo, appears. Caliban believes the jester is one of the devils sent by Prospero to torment him for his cursing and laggard service. Caliban throws himself on the ground and covers up with his cloak, hoping the "devil" won't notice him.

Trinculo is more concerned with getting out of the storm. He sees Caliban sprawled on the ground (and smells him, too) and thinks he's an islander struck by lightning. Trinculo crawls under Caliban's cloak to wait out the storm. In staggers Stephano, a drunken steward who had come ashore riding a barrel of wine.

He has fashioned a "bottle" out of tree bark and, thus fortified, has gone looking for other survivors.

Stephano begins singing and Caliban begs him not to torment him (sober folk still do much the same when passing karaoke bars). Stephano gives Caliban wine to stop his shaking. Trinculo reveals himself, and they all proceed to get very drunk together. Caliban is so impressed with the effects of drink that he makes Stephano his master and kisses his shoe. Before long, Caliban urges Stephano to kill Prospero and marry Miranda. Stephano drunkenly agrees, and they set out. Ariel makes music, which they follow through thorn and briar only to end up mired in a swamp.

Prospero sets Ferdinand to moving a thousand logs and has withdrawn to watch the two young folk. Miranda is so distressed by her father's demands that she offers to move the wood for Ferdinand. He declares that having her sympathy makes the labor easy. They both declare their passion for each other, and from his vantage, Prospero is satisfied.

The king's party is still searching for Ferdinand

while Sebastian and Antonio are still whispering about killing Alonso and Gonzalo. Prospero enters invisibly and sends in strangely shaped spirits bowing, scraping and bearing a feast. The spirits indicate through gesture that the king should eat. As the group prepares to eat, Ariel, in the guise of a harpy, appears and snatches away the feast. He then chides them, saying they are unfit to live because of their sins. Alonzo, Antonio and Sebastian draw their swords. Ariel scoffs and tells them their swords are useless and that he will drive them mad. He tells them that their usurpation of Prospero's title has made the sea and wind rise up against them.

The spirit shapes return and take away the table. Alonso, Antonio and Sebastian have had their wits soundly rattled and exit with their retinue in tow. Prospero returns to tell Ferdinand and Miranda that they may wed. But he warns Ferdinand not to get fresh with her before the marriage rites or Prospero will put a curse on him. Ferdinand swears to keep a rein on his passions, but a short time later Prospero warns him yet again. (Prospero was well aware of the nature of young men.)

Prospero conjures up a pageant to amuse the young couple. Iris, Ceres and Juno appear to bless the couple's union. Nymphs and reapers appear and engage in a pretty dance. As the dance ends, Prospero remembers that Caliban, Stephano and Trinculo are still floundering around in a swamp. He sends Ariel to leave rich garments for them to find. Stephano and Trinculo put on the garments; then Ariel sends magical hunters and hounds to harry them.

Prospero tells Ariel that he will soon be free and that he himself will break his staff and bury his book of spells after this last act of magic to set things right. Prospero then creates a charmed circle and bids Ariel to lead the now-mad Alonso, Antonio and Sebastian into the circle, where he casts a spell to keep them still. Prospero attires himself in the garb he had worn as duke and returns them to their senses. He tells them who he is and then forgives them. He reunites Alonso with Ferdinand, who tells his father that he is betrothed to Miranda. Alonso blesses the marriage, and the group retires to Prospero's house to hear the tale of his exile.

The play ends with Prospero addressing the audience directly, asking their indulgence and that they release him from his role with their applause.

THE WINTER'S TALE

A jealous man can be a pain in the neck, but a jealous king is a royal pain. Leontes, king of Sicilia, has everything. He's king; he has a pretty and pregnant wife; his son, Mamillius, is growing up to be a good young man who'll make a good leader.

His friend, King Polixenes, has been visiting from Bohemia. King Leontes wants Polixenes to extend his visit, but Polixenes says he has to return. Leontes then tells his wife, Hermione, to persuade Polixenes to stay longer. Polixenes gives in and, from this little thread, Leontes conjures the whole cloth of adultery. One of his courtiers, Camillo, attempts to convince Leontes that he's wrong, but Leontes wants Camillo to poison Polixenes.

Polixenes and Camillo flee the country, but Hermione ends up in prison where she gives birth to a girl child. Leontes refuses to accept the child as his, even though an oracle says Hermione is innocent. Mamillius dies from despair over what his father is doing to his mother. When Hermione learns of Mamillius's death, she dies, and her friend Paulina takes away her body. Leontes tells his servant, Antigonus, to leave the baby girl exposed in the wilderness. Hermione's ghost appears to Antigonus in a dream, telling him to take the child to Bohemia. Antigonus leaves the baby in a remote spot but wraps her in gold cloth and leaves her with gold for her keep. Then a bear eats him. A shepherd finds the baby and raises her as his own.

Back in Sicilia, Leontes has had a change of heart and feels terrible about his wife's death. Hermione's friend Paulina exacts a promise from him that he won't remarry until he meets her equal.

Flash ahead sixteen years. Camillo wants to go back to Sicilia but Polixenes says he needs him at court. Polixenes's son, Florizel, is in love with a pretty shepherd girl named Perdita, and Polixenes is fit to be tied. Polixenes, in disguise, sneaks to a festival where Perdita is with her adoptive shepherd father. The king threat-

Two Noble Kinsmen

Theseus, the duke of Athens, and Hippolyta, the Amazon queen, are preparing to marry when a trio of widowed queens enter. King Creon of Thebes has killed their husbands and left the bodies unburied, which means their souls are in torment. The queens beg Theseus to teach Creon a lesson. Right now.

Palamon and Arcite, the two noble kinsmen, have decided to leave King Creon's court because he's such a miscreant. When they hear that Thebes is under attack, however, the two kinsmen go to war for Thebes, since it would be dishonorable to leave at that time. Thebes loses and the two are taken prisoner. But that's not so bad, they say, they have each other for comfort; their great friendship will last their whole lives, etc. This lasts about ten minutes until they see Hippolyta's sister, Emilia, through the bars of the jail window, and both fall in love.

They squabble and decide that, when free, they'll duel for the right to court her. Arcite is freed, banished, puts on a disguise, wins a wrestling competition and becomes a courtier for Emilia. Palamon escapes (helped by the jailer's daughter who's fallen for him), meets Arcite in the woods and goes off to duel. When the jailer's daughter can't find Palamon, she decides wild beasts have eaten him. She goes mad and gets stand-in work as an actress. She's later cured when her boyfriend dresses up like Palamon and takes her to bed.

The duke, Theseus, allows Palamon and Arcite to duel for Emilia, but not to the death. Palamon loses; Arcite is set to marry Emilia but is crushed by his horse. Even though Palamon gets the girl, he grieves for his noble kinsman.

Most Shakespearean scholars now believe that The Two Noble Kinsmen was a collaboration between Shakespeare and John Fletcher. They agree that Shakespeare's hand is evident in the first and fifth acts.

ens to have them killed if Perdita sees his son again. Florizel won't abandon her. Camillo agrees to help the young people escape to Sicilia, but he really intends to tell Polixenes so he can follow them and finally get back to Sicilia himself.

They all end up in Sicilia. The old shepherd who raised Perdita has papers indicating where she came from. Leontes accepts her as his daughter. Paulina comes to court and tells everyone she has a statue of Hermione to show them. They go to her house and marvel at the statue. The king regrets how he treated his wife. Then the statue comes to life, and Hermione forgives her husband (and this should tell you just about how long a woman will hold a grudge). Polixenes and Leontes agree that their children should marry, and Paulina and Camillo are married as well.

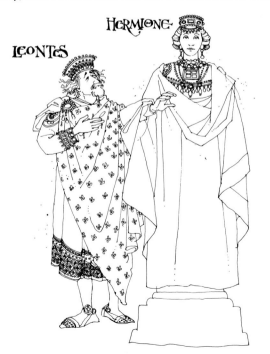

LEONTES HERMIONE

PERICLES, PRINCE OF TYRE

As long as the father-daughter incest doesn't put you off in the first act, this is really a very sweet story. Pericles comes to court the daughter of King Antiochus. He must answer a riddle or be killed like previous swains. Pericles figures out the riddle (it reveals the incest) but doesn't come out with it. He later flees but decides to go traveling to keep Antiochus's wrath from destroying his country.

Pericles finds love with Thaisa, daughter of King Simonides of Pentapolis. They marry but must go back to Tyre. (Antiochus and his daughter have been destroyed by a fire from Heaven). Thaisa gives birth to a daughter during a storm at sea and falls into a coma that resembles death. The superstitious sailors demand that she be chucked overboard. She's rescued by a doctor who recognizes that she isn't dead and heals her. The daughter, Marina, is raised by a king and queen who owe Pericles big favors, but when she's sixteen the queen tries to have her murdered. She's captured instead by pirates, is sold to a brothel and talks her way out of

there. The king and queen tell her father she died in her sleep. (They get killed later.) Pericles falls into deep melancholy. Marina is taken to meet the sad wanderer, neither knowing who the other is, and tells her story. Then the goddess Diana tells him to go to her temple, where Pericles also finds his wife alive in the cloister. Marina marries the governor of Mytilene, Lysimachus, and they go off to rule Tyre, while her reunited parents go to Pentapolis.

Hell in the Theater

Every good theater had one. The cellar under the stage, or sub-stage, was called the Hell and could serve as that infernal place, a dungeon or even a wine cellar. The Globe's Hell was the place from which the ghost of Hamlet's father could bellow, "Swear!" But he may have been bellowing partly because his feet were wet. The Globe was built between a ditch and a marsh, so it's likely that its Hell was more dank than fiery.

CYMBELINE

This play should have been called "Imogen" or, better still, "A Pure but Bland Princess Beset by Creeps and Idiots." Imogen's father, King Cymbeline, is one of the idiots. Manipulated by Imogen's stepmother, the queen (major creep), Cymbeline wants Imogen to marry her stepbrother, Cloten, a creep and a cretin to boot. Small problem: Imogen has already married Posthumus, a nice enough fellow but also an idiot. Cymbeline's response is to banish Posthumus and lock up Imogen.

A little history: twenty years previous, the king banished the loyal Lord Belarius, who convinced a nursemaid to steal Cymbeline's two baby princes, elope with him to Wales and live in a cave. The princes have grown up true to their breeding and are brave, noble and honest.

In Rome, Posthumus bets Iachimo that Imogen is chaste. Iachimo comes to Britain and tricks Imogen into having a trunk stored in her room.

IACHIMO

That night, he hides in the trunk in order to sneak into her chamber, make note of a few of Imogen's discreet birthmarks and steal her bracelet. Then he returns to Rome, where he dupes Posthumus into thinking she has been unfaithful. Posthumus sends his servant Pisanio to kill her, but he doesn't; he takes her to Wales. Cloten follows, dressed in Posthumus's clothes, intent on ravishing her. Imogen dresses like a boy, meets her brothers, drinks a poison that makes her seem dead and gets put near Cloten's body (minus a head thanks to her elder brother, whom Cloten insulted) to await burial. She awakens, thinks it's Posthumus's dead body, grieves, meets a Roman ambassador (who's come to declare war because the queen has convinced the king not to pay tribute) and becomes his page.

Belarius, the two princes and Posthumus help Britain win, the queen commits suicide because Cloten is missing, and everyone else reveals their true identities, gets forgiven and lives happily ever after.

Who Really Wrote Shakespeare?

With the typical bad planning that most artists experience at one time or another, the writer of plays attributed to Shakespeare died without leaving clear-cut, irrefutable, signed in triplicate, sealed, wrapped in goatskin and authenticated by experts, proof positive of his or her identity. Remember, this was the 1600s, when you didn't need a license to drive a carriage and people left home without their American Express cards every day.

William Shakespeare hadn't been dead all that long when people began to wonder if he really wrote the plays. This may have been a response to all the genuflecting toward Stratford and general worship of all things Shakespearean. Nonetheless, once the opposing camps got going, the controversy and conspiracy theories grew like "authentic" pieces of the mulberry tree under which Shakespeare supposedly wrote.

Sir Francis Bacon was an early contender for the Shakespearean crown, although examples of Sir Francis's writing offer about as good a stylistic match as that between Thomas Hardy and Jack Kerouac. Then there were the people who believed that there was no William Shakespeare, there was only a low born son of a glovemaker named William Shaxper who lacked the wit and education to write his name, much less Hamlet. They could be right. Or they could be snobs who preferred to attribute the writing to Edward de Vere. As the seventeenth earl of Oxford, de Vere had birth, breeding and education, and he would probably have needed to keep his identity secret since the theater was a déclassé career choice among the gentry.

Some people have speculated that Queen Elizabeth I herself might have written the plays. There certainly are enough strong, unconventional women in the plays to make such speculation possible. Then again, maybe Shakespeare was Queen Elizabeth, pulling off the acting coup of a lifetime and with a stunning wardrobe as well.

In the end, it doesn't matter a jot who wrote Shakespeare's plays. The controversy is a conflict between worshippers and is as silly a debate as how many angels can dance on the head of a pin. What the argument does say about us is that we are in love with celebrity more than we understand inspiration. To worship Shakespeare for writing Shakespeare's plays is like the worshipping electrical wires for producing electricity.

Inspiration moves through us. No one possesses it for eternity. The playwright produced work that was awful, and some of the plays that seemed terrific in his day now seem wanting. The plays that we love so much touch us because they say something universal about the human condition. After four hundred years, the passion of Romeo and Juliet, the distress of Hamlet, the ambition of Macbeth all still make sense and evoke a visceral response that a painstakingly researched and authenticated biography of the writer never could. The playwright was able to get himself out of the way and to write from the heart of us all.

1. Arcite and Palamon, *The Two Noble Kinsmen*
2. King Lear and Cordelia, *King Lear*
3. The Duke of Vienna, *Measure for Measure*
4. Timon, *Timon of Athens*
5. Pericles, *Pericles, Prince of Tyre*
6. Henry VIII, *Henry the Eighth*
7. Romeo and Juliet, *Romeo and Juliet*
8. Prospero, *The Tempest*
8a. Ariel, *The Tempest*
8b. Caliban, *The Tempest*
9. Titania and the Faeries, *A Midsummer Night's Dream*
10. Lady Macbeth, *Macbeth*
11. Ophelia, *Hamlet*
12. Cleopatra, *Antony and Cleopatra*
13. Dogberry and Verges, *Much Ado about Nothing*
14. Helena, *All's Well That Ends Well*
15. Berowne and Rosaline, *Love's Labour's Lost*
16. Viola, *Twelfth Night*
17. Julia, *The Two Gentlemen of Verona*
18. Rosalind, *As You Like It*
19. Portia, *The Merchant of Venice*
20. Sir John Falstaff, *The Merry Wives of Windsor*
21. Petruchio, *The Taming of the Shrew*

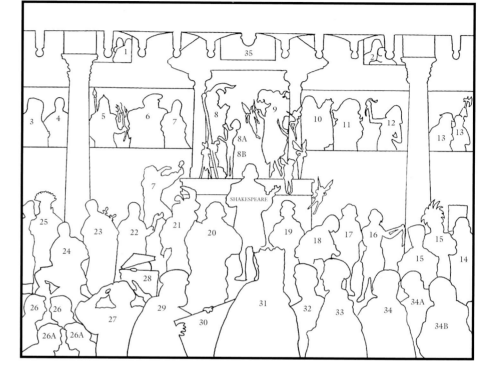

22. Othello, *Othello*
23. Julius Caesar, *Julius Caesar*
24. Titus, *Titus Andronicus*
25. Caius Marcius Coriolanus, *Coriolanus*
26. Antipholus of Syracuse, Antipholus of Ephesus, *The Comedy of Errors*
26a. Dromio of Syracuse, Dromio of Ephesus, *The Comedy of Errors*

27. King John, *King John*
28. Iachimo, *Cymbeline*
29. Richard III, *Richard the Third*
30. Richard II, *Richard the Second*
31. Henry IV, *Henry the Fourth*
32. Henry VI, *Henry the Sixth*
33. Henry V, *Henry the Fifth*

34. Troilus, *Troilus and Cressida*
34a. Pandarus, *Troilus and Cressida*
34b. Cressida, *Troilus and Cressida*
35. Antigonus and Perdita, *The Winter's Tale*

---·❦·---

Our revels now are ended. These our actors,
As I foretold you, were all spirits and
Are melted into air, into thin air;
And like the baseless fabric of this vision,
The cloud-capped towers, the gorgeous palaces,
The solemn temples, the great globe itself,
Yea, all which it inherit, shall dissolve,
And, like this insubstantial pageant faded,
Leave not a rack behind. We are such stuff
As dreams are made on, and our little life
Is rounded with a sleep.

—Prospero, The Tempest, Act 4, Scene 1

INDEX

All's Well That Ends Well	40	Measure for Measure	39
Antony and Cleopatra	96	The Merchant of Venice	42
As You Like It	25	The Merry Wives of Windsor	32
The Comedy of Errors	20	A Midsummer Night's Dream	8
Coriolanus	98	Much Ado About Nothing	13
Cymbeline	108	Othello	57
Hamlet	46	Pericles, Prince of Tyre	107
Henry the Eighth	93	Richard the Second	77
Henry the Fifth	81	Richard the Third	88
Henry the Fourth, Part One	78	Romeo and Juliet	66
Henry the Fourth, Part Two	79	The Taming of the Shrew	18
Henry the Sixth, Part One	83	The Tempest	100
Henry the Sixth, Part Two	85	Timon of Athens	62
Henry the Sixth, Part Three	86	Titus Andronicus	64
Julius Caesar	95	Troilus and Cressida	37
King John	94	Two Gentlemen of Verona	34
King Lear	52	Twelfth Night	30
Love's Labours's Lost	22	Two Noble Kinsmen	106
Macbeth	71	The Winter's Tale	105